EMIL KOSA JR.

1903–1968

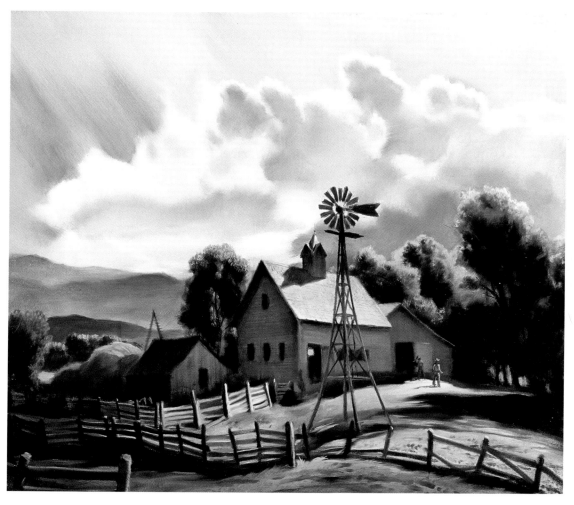

Every Cloud Has Its Silver Lining. Oil on canvas 36 x 42. Gardena High Collection.

BY GORDON T. McCLELLAND

Hillcrest Press, Inc.
P.O. Box 10636
Beverly Hills, CA 90210

ISBN 0-914589-06-7

Edited by Jay T. Last and Zena Pearlstone
Designed by Gordon T. McClelland
Graphic Production by Birgitta Thornton
Photography by Mike Rupp

Printed and Bound in Japan by Dai Nippon
Typography by Sycamore Studios, Tustin, California

ACKNOWLEDGMENTS

The majority of biographical information in this book came from Kosa's personal scrap books, exhibition catalogs, files and notes which Elizabeth Kosa graciously made available. Additional information was obtained through interviews with Rex Brandt, Hans Burkhardt, George Gibson, Lenard Kester, Arthur Millier Jr., Marion (Kosa) Saund and Mathew Yuricich.

George Stern, Janet B. Dominik, Gary Breitweiser, Phila McDaiel, Sam Delcamp, Peggy Still and Fred Mintz helped to locate and photograph art for reproduction. Many works listed as "private collection" are from the Elizabeth Kosa Revocable Trust. The Fuller Foundation made them available to be photographed. Private collectors that allowed us to photograph and reproduce their paintings are credited in the caption under their picture. The Stary-Sheets Gallery supplied Millard Sheets quotes and shared other information from their files.

Our sincere thanks to all of these people for helping to make this book possible.

Table of Contents

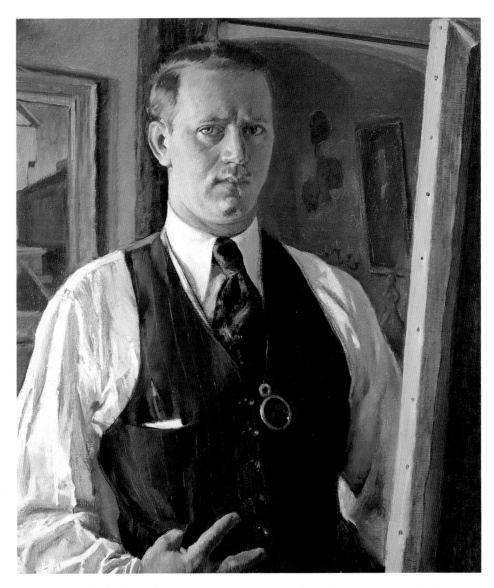

Self Portrait - With Moustache. Oil on canvas 32 x 28. Gary Breitweiser-Studio 2.

Foreword

It is said of the artist that he sees things not as they are but as he is - this can truly be said of Emil Kosa Jr.

Those of us who knew Emil and there are many, recall with fondness his generous friendship, his knowledge and his keen sense of humor. No one loved to hear a story, or tell one, more than Kosa and when I look at one of his paintings it sparkles with life as he lived it, full of gusto and the joy of being.

He loved the country of his adoption, especially his beloved California, and he responded with all his creative being to her rugged mountains and sea shores, her golden hills, sunlit cities and ranches. This world all around him met with his keen understanding and appreciation. Landscapes and vistas of every description were there for all of us to see and enjoy, but under his poetic and masterly guidance they became in paint, on canvas, a paean to the glories and beauty we all tend to accept as an everyday occurence.

Emil was my good friend and I was privileged to share with him many of his painting days and experiences. I miss his companionship.

GEORGE GIBSON

1

1903–1930

Emil Jean Kosa Jr. was born in Paris November 28, 1903. His father was an artist/craftsman of Czechoslovakian descent and his mother, Jeanne Mares Kosa, a pianist at the Paris Opera, was of French descent. When Kosa was three years old his mother died of tuberculosis and the following year his father remarried.

In 1908 the Kosa family moved to Cape Cod, Massachusetts, so that Emil Kosa Sr. could work with his long time friend Alphonse Mucha, designing theatrical posters and painting a series of murals. During this period Kosa attended public schools and received basic art instruction from his father. According to family members, he seemed always to have pencil and paper in hand, drew everything in sight and thoroughly enjoyed the process.

By 1912 Kosa had two sisters, Marion and Jarmila. That year the family moved back to Czechoslovakia (Austria-Hungary) and soon were caught in the middle of World War I. Kosa's father became a member of the Red Cross and father and son travelled together. Food was scarce and working with the Red Cross both served the war effort and provided food for the family. Kosa's writings include stories of being jailed, then freed, stealing a train and ending up in the wrong country and of being hidden in a sack of potatoes. There is little doubt that these experiences left deep emotional scars, and initiated Kosa's hatred of wars and oppressive governments.

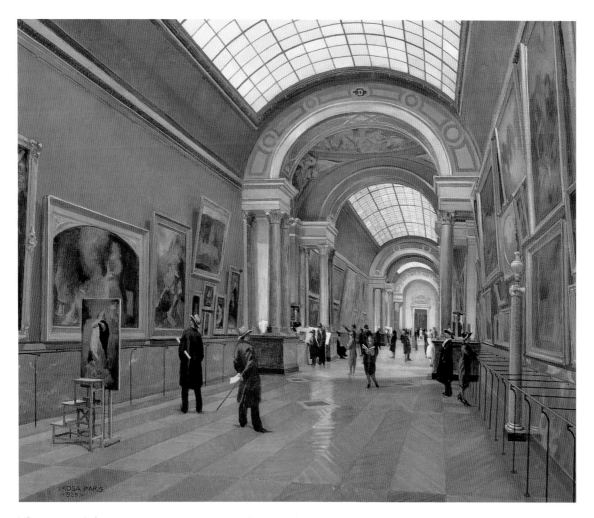

The Louvre. Oil on canvas 33 x 40. Mr. and Mrs. John K. Otis Collection.

After the war the Kosa family moved back to America, leaving Emil to finish his education at the Academy of Fine Arts in Prague. While little information exists about this period of his life, the following personal story appeared in an article on drawing which Kosa wrote for *American Artist* magazine.

"I was about sixteen years old and had my first year of the academy of fine arts behind me. During every vacation I would go out into the country to sketch and pick up a penny here and there by painting theatre drops for amateurs, fancy signs, and pictures of all sorts. Now, I didn't know very much, but a bishop, an old friend of my dad's, wanted to help me out and ordered a picture of a church in which he served for the first time as a pastor: a sentimental reason. He said he'd pay me well. Ah, I painted a fine picture of that church. Well, I thought so then, anyway. But I had difficulty in drawing any people; so I left them out and delivered my masterpiece.

The bishop seemed to like the painting but wondered why I hadn't placed any people in it, as he thought they would enliven the picture?

Oh, boy. I turned as pale as a sheet that hasn't been laundered for a month. I had to think fast to get out of it: so I told him that his influence there was so great that when I painted the picture all the people were at service in the church. Well, he looked at me, smiled, and said he was glad to hear that, but he would pay me only after the services were over and the people came out of the church — on my painting. Well, you see, that was a good lesson. I had to draw them, and eventually I got paid.

Now that was not important, but the important thing was that laziness had to be overcome. And laziness, that malady of so many artists and would-be artists is a bad thing. Because it is only through hard work, and very hard work, that one can learn to draw well. Without that, it would be futile to advise one about any procedure or technique at all."

In addition to art instruction, Kosa received classical violin lessons throughout his childhood. By his mid-teens he was so advanced that had he not chosen to pursue an art career, he could easily have become a professional musician. He continued to play the violin, on occasion, throughout his life.

In the spring of 1921 Kosa graduated from the Academy in Prague and sailed for America to see his family in California. After brief stays in New York and Colorado he arrived in Hollywood.

Kosa immediately found employment as a mural artist and designer, working for decorating firms and architects, he was proficient at fresco painting, a form of mural painting that was unfamilier to most California artists. In addition, he continued his art education by taking classes at the California Art Institute in Los Angeles. Of this era Joseph S. Roucek wrote:

"I shall never forget the years of 1923 to 1925, when I lived with the Kosas in Hollywood. I was a college student at Occidental College. Like thousands of other students at that time, I worked my way through college. It was a hard struggle to make the ends meet. But they met. For I had two friends who were not only good American Czechs but also Bohemians by profession and knew what such years of struggle for a living mean. Both always wanted me to be their perpetual houseguest; they always carefully took care of all the expenses on all the trips that we took together. They always made me feel that they were delighted to have me around as a struggling intellectual — and all they asked in return were a few hours weekly of music, especially soft music.

They made my life for those two years not only easier, but quite romantic. The "old" Kosa, with his flashing eyes, black beard and artistic temperment, fascinated me and others with his typical artistic behavior. He had his artistic fits, working furiously at times, brooding at other times, and soothing once in a while his temper by long-winded lectures on ignorance of art in Hollywood.

The "young" Kosa followed in his father's footsteps. Full of temperament, he enticed all his friends with his heart of gold, his indiffer-

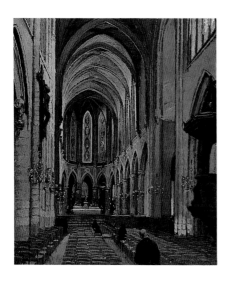

Cathedral. Oil on canvas 28 x 22.
The Fuller Foundation.

ence to the business aspects of art, his striving for perfection in that field of human endeavor.

Those were the days when we lived on a sloping hill of Sunset Boulevard in Hollywood. They have impressed themselves indelibly on my mind. And I have always hoped that the Kosas would always remember."

During the summer of 1925 Roucek and Kosa decided to travel to Hawaii with the thought of working there. Discovering that plantations paid only fifteen cents per hour they abandoned the idea of working but did spend the summer in the Islands. After returning to Hollywood in the fall, Kosa continued his work in the field of decorative arts and also painted portraits. On occasion he produced oil paintings depicting Southern California landscape subjects.

After becoming a naturalized citizen of the United States in 1927, Kosa went back to Europe for a one-year study program at L'Ecole des Beaux Arts in Paris. There he continued to study drawing and painting. His primary instructor was Pierre Laurens and his main inspiration the old master painters, particularly Rembrandt.

In addition to his academic studies, Kosa received instruction from Frank Kupka, a friend of his father, who lived in Paris. Kupka was a pioneer of abstract art and avidly committed to modern forms of artistic expression. While this may have rounded out Kosa's art education, radical abstraction seldom found its way into his paintings.

Upon his return to California in 1928, Kosa married Mary Odisho. The following year the depression hit, making the first few years of their marriage a financially difficult period. Kosa found employment as a mural artist and designer in Sacramento. Generally he painted large murals in churches and public buildings. When possible, he would go out on location to draw and paint landscape subjects and interesting old buildings.

2

THE 1930's

The 1930s were an exciting period for Kosa. On June 20, 1930 his wife gave birth to a daughter Lillian. At the same time he was beginning to receive increased recognition for his work in the fine arts.

Up to this time Kosa had worked hard in the decorative arts field and did not vigorouly pursue his fine arts career. While in Paris he had recognized the trends in painting toward abstraction and non-objective art but had no interest in following these paths himself. Kosa was discouraged by the fact that the representational style that he loved was considered old fashioned and even regressive by many writers and critics in Paris and New York. In an interview he credited Millard Sheets with helping him restore his self-confidence and resolve his confusion about the future of art. "You know how to paint" said Millard. "Go out and paint to suit yourself. Paris is all right, but we have a job to do here in America and California."

Kosa heeded Sheets' advice and began painting and exhibiting with a passion. While he liked to paint with oils, it seemed watercolors were best suited for capturing the plays of light and shadow that he sought to depict. On October 18, 1931 the Los Angeles Times printed this review of Kosa's first one man show of watercolor paintings:

"The exhibition of watercolors by Emil Kosa Jr., held recently at the Assistance League Art Room, revealed one of the most satisfactory artists working here in the aquarelle medium. Kosa's pictures, made

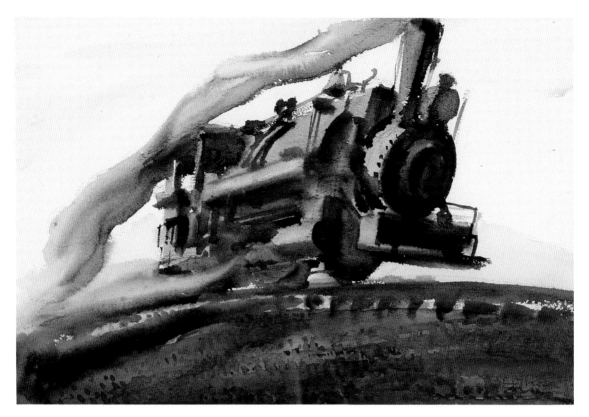

Traveling Engine. Watercolor 15 x 22. Elizabeth Kosa Collection. This painting is part of a series Kosa produced which depict industrial vehicles. Trains, steam rollers, crains, steam shovels and trucks became subject for his imaginative and spontaneously painted works of art. All of these watercolors were painted right on location and probably took less than one hour to complete. In the early 1930s when Kosa first exhibited *Traveling Engine* it was repeatedly singled out for top awards and was reproduced in several newspapers accompanying reviews of art exhibitions it was included in. Since that time it has been included in several major exhibitions featuring American paintings from the 1930s era.

hereabouts and dealing with those authentically American old houses one finds on Bunker Hill, the tile roof hill communities of Hollywood, ships at the harbor and other everyday subjects, have warmth, strong color and a serenity of tone and composition that mark him not only as a gifted artist, but also as one who has gained control over a refractory medium. One of his harbor water colors won first prize in that medium at the last Los Angeles County Fair.''

One of the main art events in Los Angeles during this era was the annual exhibition and dinner sponsored by the California Water Color Society. While this organization had been in existence for ten years, it was, at this point, experiencing major changes. A number of young

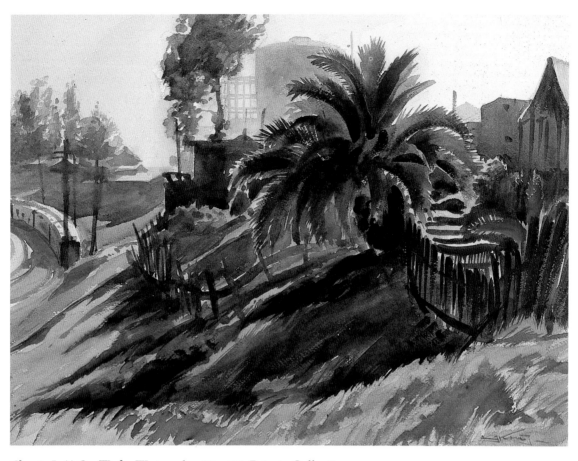

Close to L.A. Gas Works. Watercolor 19 x 25. Private Collection.

energetic watercolor painters, including Kosa, had become members and their unique approach to painting was receiving positive reviews. Some of the prominent members included Millard Sheets, Phil Dike, Milford Zornes, Barse Miller, Paul Sample, Lee Blair, and Hardie Gramatky. Each of these artists was committed to developing bold new ways of painting with watercolors on paper.

Traditionally artists would draw detailed pencil outlines and then proceed to carefully color the drawing. Weeks were often needed to faithfully reproduce the details of the landscape scenes. Usually these were small in size and produced in the studio. Kosa had no interest in perpetuating this tradition. He went out on location, set up and began painting with little or no pencil outlines. A 15 by 22 inch painting took only a few hours to complete. He explored many different techniques including wet into wet, a method of saturating the paper with water before painting on it. This produced beautiful, soft edges and worked well when blending colors. He tried using many different sizes of paper, with varied textures. It was a period of lively experimentation with exciting results.

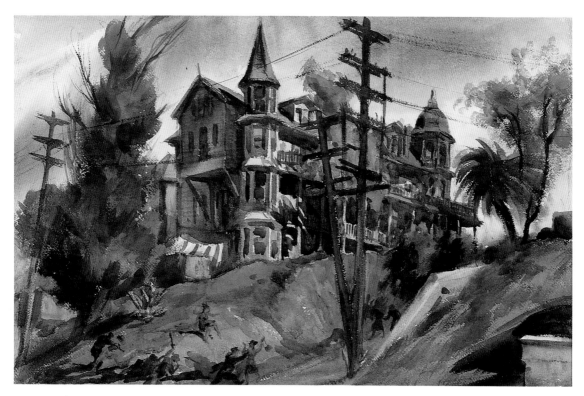

Old Testimony. Watercolor 19 x 30. The Buck Collection.

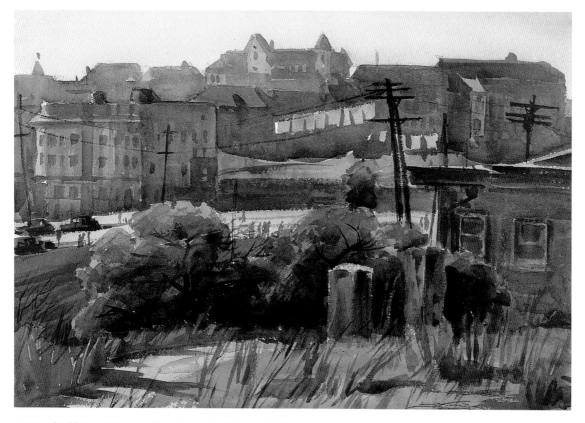

A Bit of Old L.A. Watercolor 22 x 30. Private Collection.

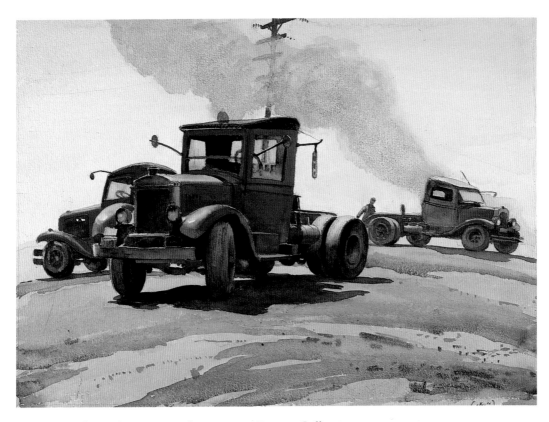

Truckers' Gathering Spot. Watercolor 18 x 25. Private Collection.

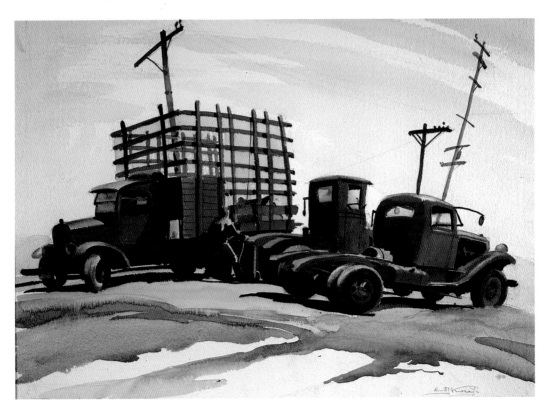

Potential Blowouts. Watercolor 18 x 25. Collection of Mr. and Mrs. Anthony Podell.

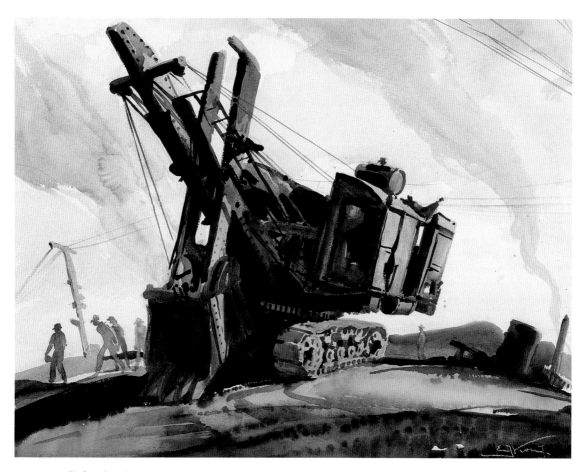

Romance of The Shovel. Watercolor 18 x 22. The Zander Collection.

The subjects he chose to depict were often different than those chosen by traditional watercolorists. Kosa was painting depictions of trains, oil wells, industrial city scenes, and trucks parked for repairs. These paintings did not sell well at the time, but other artists appreciated his departure and often chose to award him top prizes in competetive art exhibitions.

By the late 1930s Kosa was establishing a national reputation as one of the West Coast's leading watercolor artists. He was exhibiting in the annual New York shows of the American Watercolor Society and of the National Academy of Design. His paintings regularly traveled across the United States with the California Water Color Society exhibitions and were often reproduced in art publications and newspaper reviews as illustrations of the best of the genre.

Increasing numbers of people began to recognize his name and his art. He was invited to participate in numerous exhibitions including prestigious annuals at the Chicago Art Institute, the Pennsylvania Academy, the Metropolitan Museum, the Carnegie Institute, and the Corcoran Gallery.

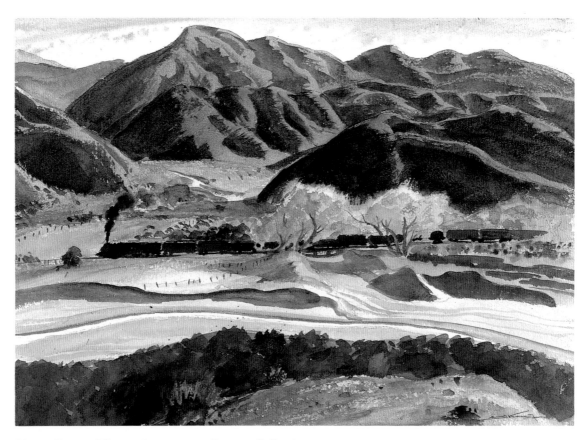

Mojave Express. Watercolor 20 x 28. Private Collection.

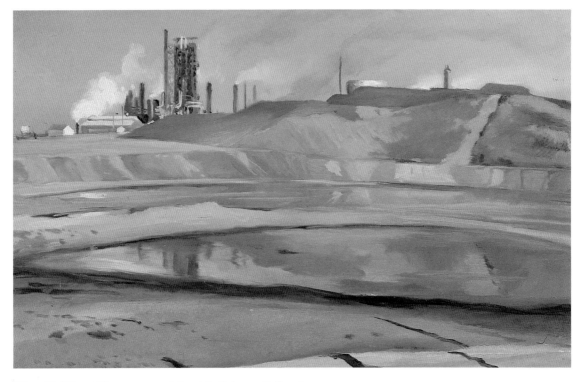

Playa Del Rey. Oil on canvas 20 x 30. Private Collection.

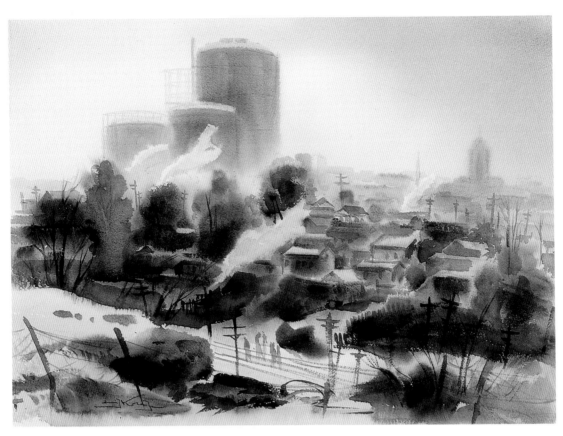

Haze Over Los Angeles. Watercolor 22 x 30. Elizabeth Kosa Collection.

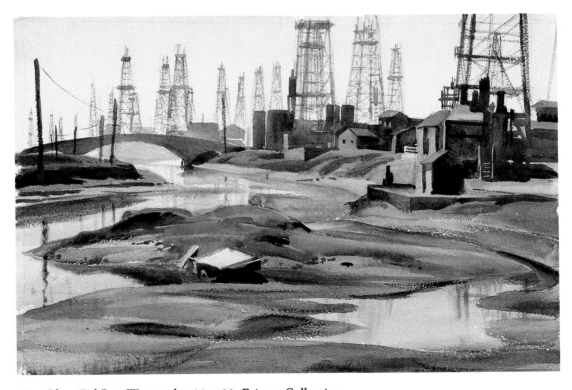

Near Playa Del Rey. Watercolor 15 x 22. Private Collection.

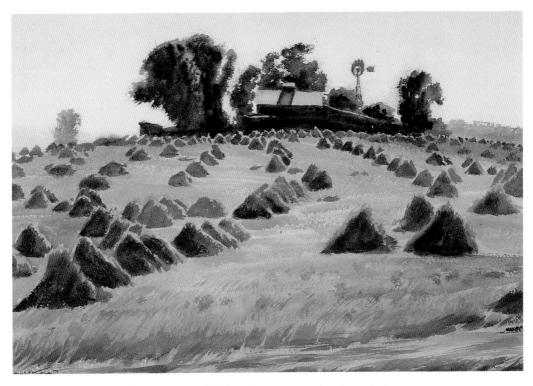

Harvest Time. Watercolor 18 x 25. Chaffey Community Art Association.

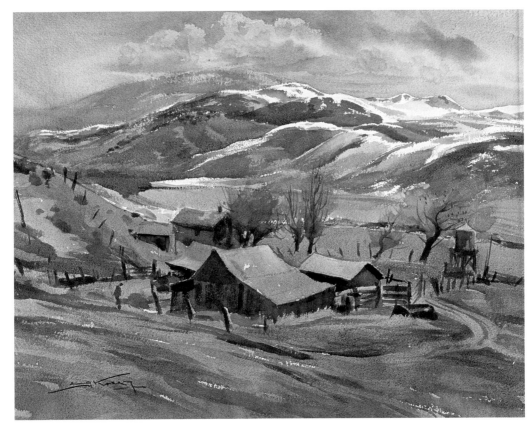

Be It Ever So Humble. Watercolor 18 x 25. Private Collection.

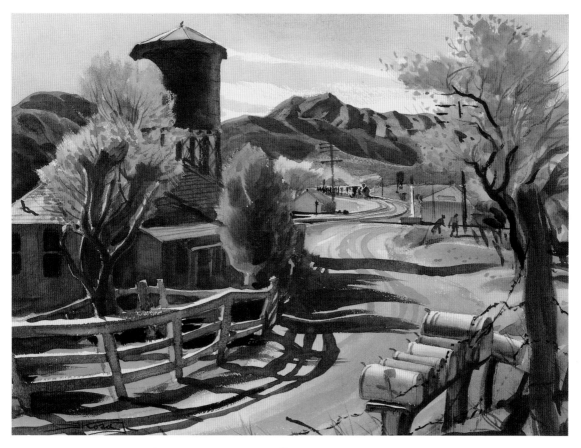

Junction At Acton. Watercolor 15 x 22. Private Collection.

Much of the success that Kosa and other California artists were enjoying was due to the American public's shifting taste toward representational art — a style to which many people could relate. Some art critics were encouraging American artists to resist the modern trends from Europe and concentrate on developing an American art. This was exemplified by American Scene or Regionalist schools led by Grant Wood in Ohio, Thomas Hart Benton in Missouri, Aaron Bohrod in Chicago, Andrew Dasburg in New Mexico and others in areas previously thought to be lacking in artistic talent. The unique style of the California artists also was seen as having this American aura.

All the publicity greatly encouraged the young Kosa. The money received from painting sales, however, did not pay the bills for Kosa and his family. In 1933, therefore, he took a job at the newly-formed special effects department at the Twentieth Century Fox Studios in Beverly Hills. Fred Sersen, head of special effects, immediately recognized Kosa's talents as a painter and gave him an influential position as an art director. Kosa held this position for most of the next thirty-five years.

3

THE 1940's

For Emil Kosa the events of the 1940s were filled with triumph and tragedy. With this decade came the highest honors he would ever receive for his art, but at the same time he painfully watched as his wife and daughter deteriorated with leukemia. His daughter, Lillian, passed away in 1943 and his wife, Mary, in 1951. Kosa found solace by pouring his feelings into his art.

The artistic acclaim Kosa began receiving in the early 1940s came soon after receiving several important awards in 1939. That year he received the Zabriskie Purchase prize from the American Watercolor Society and was elected a life member of that organization. His watercolor "Old Bear Valley" was chosen over many outstanding works including ones by Ogden Pleissner, Andrew Wyeth, and the famed British artist Sir Russell Flint. Also that year the Denver Art Museum and the Oakland Art Gallery featured special exhibits of Kosa's paintings.

Nineteen forty opened with a one-man show of watercolor paintings at the Macbeth Gallery in New York City. This was followed by a one-man show at the Los Angeles County Museum, a five-painting show at the Golden Gate International Exposition in San Francisco and several prestigious awards. Each year saw more honors and awards from all over the country. After viewing a one-man show of Kosa's paintings in November 1941, Los Angeles Times art critic Arthur Millier wrote the following:

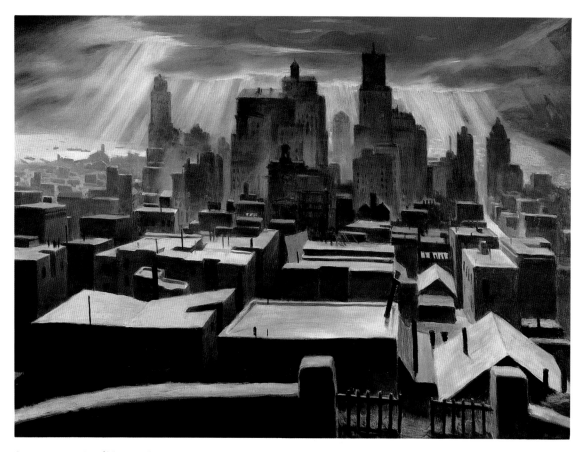

San Francisco Roof Tops. Oil on canvas 36 x 48. The Fuller Foundation. In the early 1940s Kosa began focusing his attention on producing large oil paintings. This dramatic scene of San Francisco was one of the first major canvases completed. It appeared in the *Directions of American Painting* exhibit at the Carnegie Institute, Pennsylvania, in 1941.

"Kosa—Emil J. Kosa Jr.—is the name. Last Monday he blew the lid off California landscape painting. For years the once vaunted art of landscape in this State has suffered from galloping anemia. The old-timers settled into lazy mannerisms. The younger ones handed us a bunch of precious esthetics. The ladies (heaven help me!) tied landscape up in pink and blue ribbons. We almost forgot what real landscape was like.

And then this guy Kosa, 37, with good training under his belt, kissed Willie Bioff's union and 20th Century-Fox a temporary good-by and went out to the hills and valleys of California. A big man, billowing inwardly with love of life, he went back to nature.

The results, some two dozen all-alive canvases, are at Biltmore Salon until December 13. If you don't see them you will miss a red letter event in California's art history.

For in these lovely, shining pictures Kosa has put the pants back on landscape and restored to it the manly poetry which, between ugly "realism" and thin estheticism, it had lost.

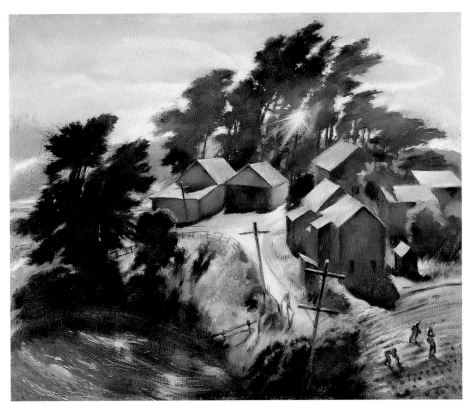

A Grand Place To Work. Oil on canvas 30 x 36. Elizabeth Kosa Collection.

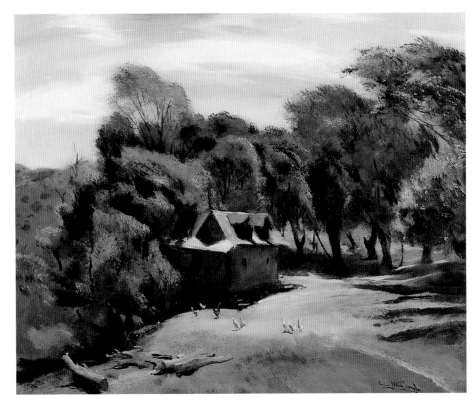

Just A Nice Old Place. Oil on canvas 25 x 30. E. Gene Crain Collection.

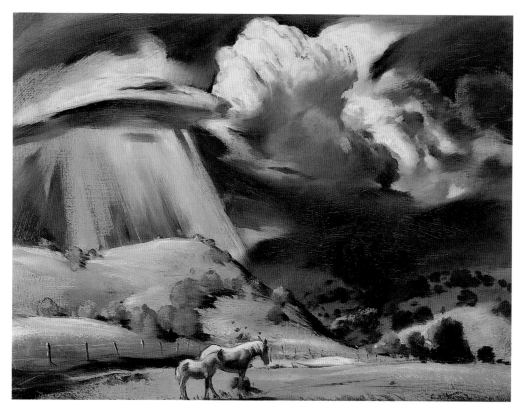

Storm At Sequoia. Oil on canvas 30 x 40. Chaffey Community Art Association.

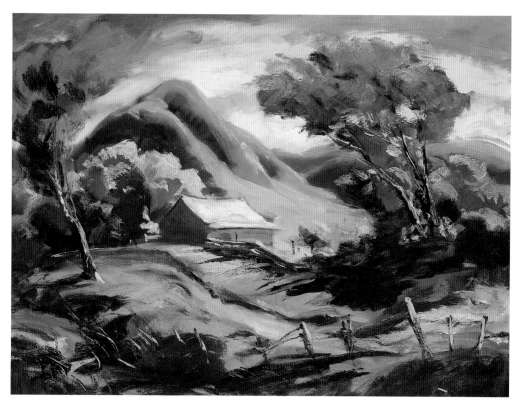

Stormy Day. Oil on canvas 32 x 40. The Buck Collection.

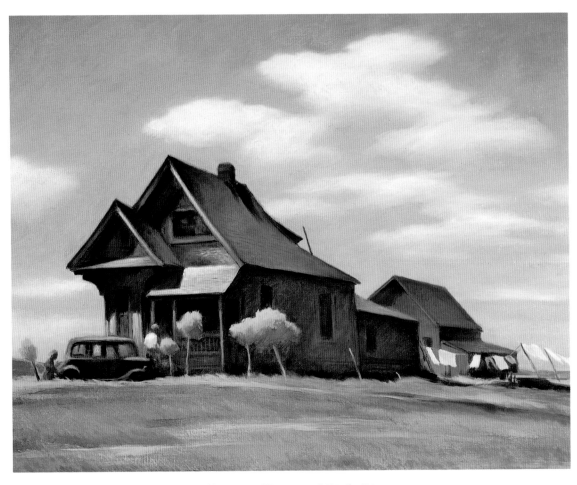

Untitled. Oil on canvas 22 x 28. Collection of James and Linda Ries.

Kosa has been coming up, now, for several years. But nothing he has previously shown prepared me for this moving panorama of California's sun and shade, swelling hills, shining skies and shimmering trees. In some pictures the fog blows in like quiet music. In others the sun blares like a trumpet, the scenes live the way things live when you step out-of-doors in high spirits, in fine health, in the fresh of a new morning.

Thank you, Emil, for my biggest art thrill of 1941. Thank you for beautiful painting. And thank you for a new standard for landscape painting in California—maybe in the whole U.S.A."

Up to this time Kosa had produced oil paintings but had primarily exhibited watercolors. This show at the Biltmore Salon in Los Angeles marked his first major one-man show of oil paintings. Most depict California landscape subjects and regional small-town views. Some were painted on location while others were produced in his studio from sketches. Usually the ones painted on location, while he was directly viewing the subject, were his finest works.

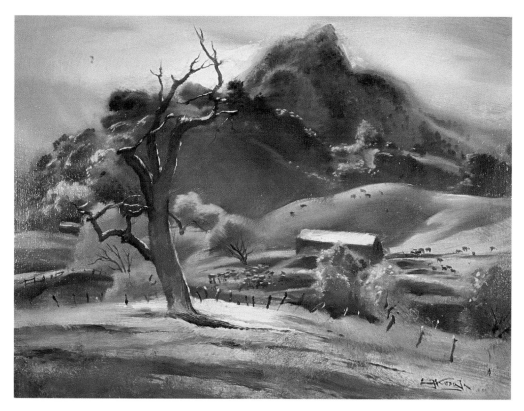

Dead Oak. Oil on canvas 24 x 36. Mr. and Mrs. Arthur Lawrence Millier Collection.

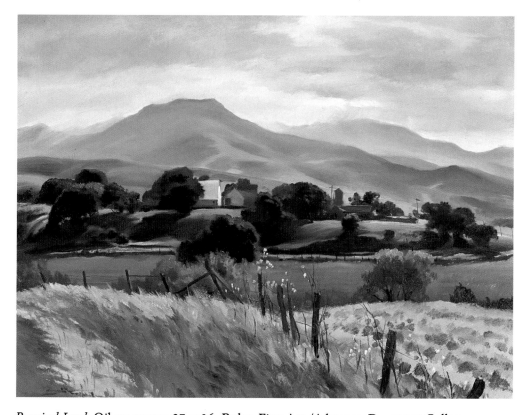

Promised Land. Oil on canvas 27 x 36. Bolen Fine Arts/Adamson-Duvannes Gallery.

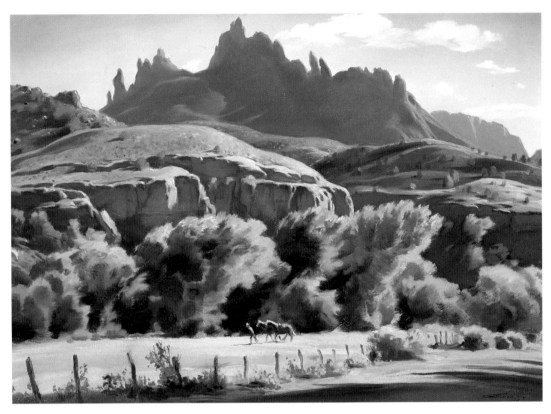

Forever And Ever. Oil on canvas 24 x 34. Dan and Maureen Murphy.

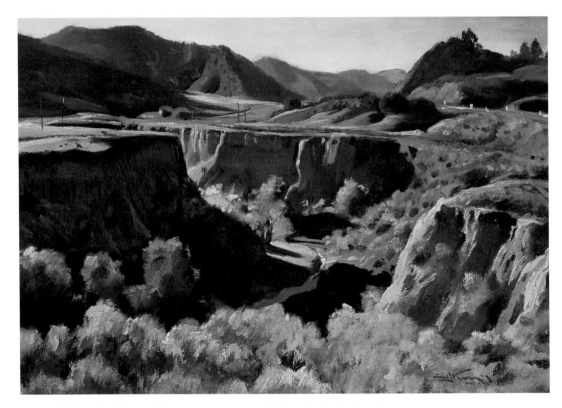

Valley of The Silver Horn. Oil on canvas 24 x 36. The Buck Collection.

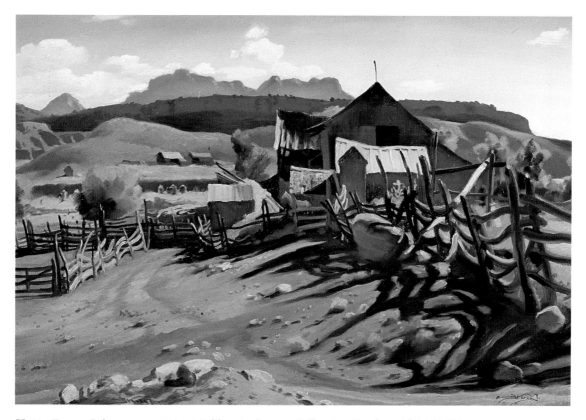

Happy Fences. Oil on canvas 24 x 36. Tim Anderson Collection. In the mid-1940s Kosa began taking extended painting excursions to Utah. An artist friend Maynard Dixon lived near Zion National Park and introduced him to the region. The above painting depicts a Utah ranch and focuses on the plays of light and shadow.

It was also during this period that Kosa began to develop the idea of painting landscape subjects while looking in the direction of the sunlight. Most artists choose to paint with the sun to their back or side, but Kosa found beauty in backlit trees, bushes and other objects. A sense of deep space thus accompanies the feeling of hot, bright sunlight in the works he painted using this method. Late afternoons, as the sun was casting long shadows across the rolling hills and just before sunset, when the light effects became most dramatic, were favored times for Kosa to paint.

While Kosa is best known for his outdoor paintings, he was also an accomplished portrait and figure painter. Between 1940 and 1968 he painted over seventy-five commissioned portraits. Some were produced using watercolors, but most were oils on canvas. His clients were Hollywood celebrities, wealthy businessmen, religious dignitaries, and politicians. Most of these works were painted rapidly while the person posed. On occasion Kosa was asked to paint a portrait while

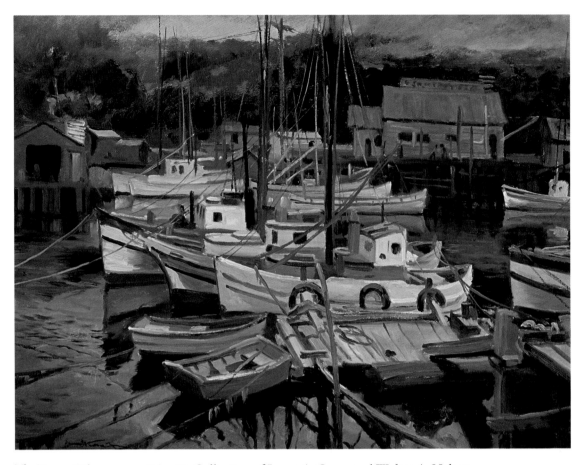

The Haven. Oil on canvas 24 x 32. Collection of James A. Coran and Walter A. Nelson-Rees. This painting depicts a harbor in Northern California near Mendocino. In the 1960s Kosa purchased property in Gualala, next to his long time friend Millard Sheets. While he never actually lived in the area Kosa painted there many times.

an audience watched. Lenard Kester, one of Kosa's friends and a fellow artist, saw one of these presentations at the Laguna Beach Museum of Art, and recalled:

"Emil Kosa propped up a watercolor paper board on a vertical easel, turned to the audience and asked an attractive young lady if she would like to pose for a portrait. Remember the painting surface was vertical for the benefit of the large audience. There followed one of the most remarkable demonstrations of the wet watercolor technique that I have ever seen. On this vertical surface, with broad wet washes, Emil proceeded to record not only a striking portrait of the model, but also a painting of astonishing beauty and brilliance. It was a breathtaking display of virtuoso wet watercolor pyrotechnics. This was not the dry-brush technique that can be done on a vertical surface, but rather wet and running wet washes that he caught up with large brushes. With magical speed, determination and knowledgeable direction, he transformed the surface into pictorial cohesion."

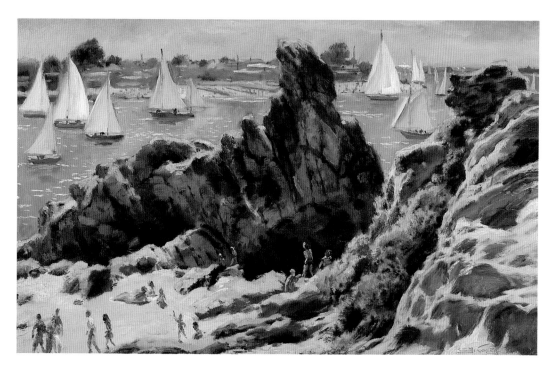

Newport Beach. Oil on canvas 22 x 34. Private Collection.

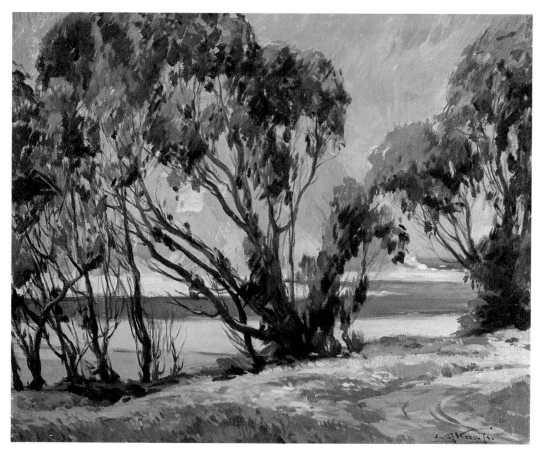

Morro Bay. Oil on canvas 25 x 30. Young's Fine Arts.

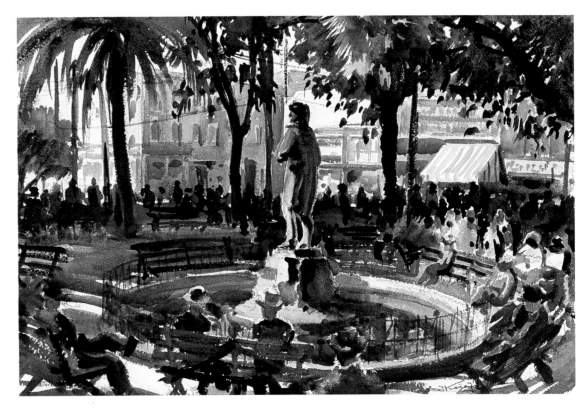

Walking Through The Park One Day. Watercolor 15 x 22. Mike and Susan Verbal Collection.

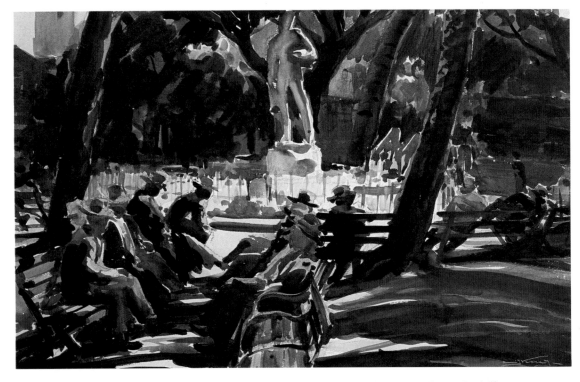

Lazy Plaza of The Angels. Watercolor 22 x 30. Collection of Mr. and Mrs. Anthony Podell.

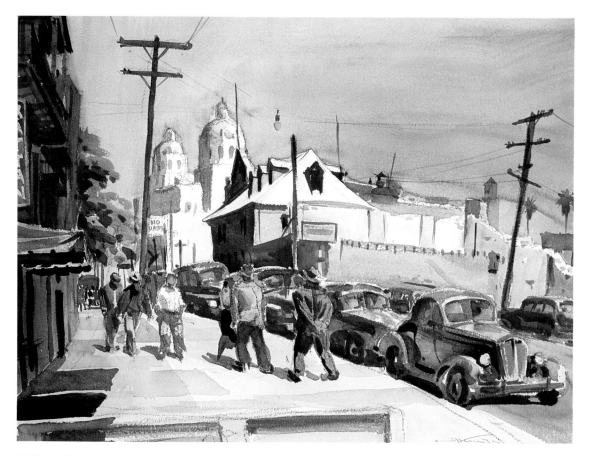

Old Lugo House. Watercolor 22 x 30. Glen and Pam Knowles Collection. Throughout his entire career Kosa set up and painted on location in downtown Los Angeles. On occasion he exhibited these works but often they went to friends or were stored away. The above painting was an exception. It was exhibited at the National Academy of Design in New York City and in a one man show in Los Angeles.

This kind of performance came from many years of practice with drawing and painting from live models. On Wednesday nights, artists from various motion picture studios in Hollywood would gather at the M.G.M. Studio Club. Kosa, Hans Burkhardt, George Gibson and others would pool their money and hire a model to pose for these life drawing sessions. Kosa often worked with charcoal, pastels, or conte crayon on large sheets of paper. Sometimes he would produce as many as five works a night—immediate impressions, drawn quickly.

On occasion he used the sketches to develop large oil paintings, but usually his major figurative paintings were done directly from models. For several years he taught figure painting classes at the Chouinard Art Institute in Los Angeles which gave him the opportunity to paint from the class models if he wished. At other times he hired models to sit at his studio.

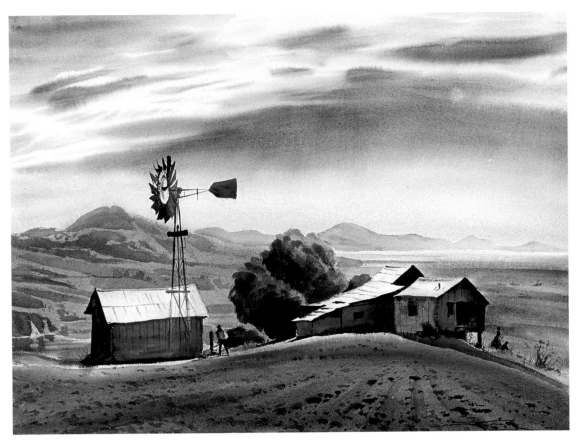

Windmill. Watercolor 18 x 25. Mrs. Lee Witte Collection.

By the time America entered World War II Kosa was nearly forty years old and not eligible for active duty in the armed services. He wrote of being addicted to news reports of the war, even though they depressed him and often effected his ability to paint. Throughout the war years the Twentieth Century-Fox Studios worked directly with the U.S. Navy Film Unit. On several occasions Kosa was called upon to work on newsreels, training films, and documentaries about the war. One important film project documented the bombing of Pearl Harbor, using live footage from that attack.

Each year Kosa would try to take at least one extended vacation. Often these amounted to painting excursions and opportunities to visit artist friends. During this era he took several trips to Northern California where he painted and visited Armin Hansen, Arthur Hill Gilbert and Maurice Logan. He took a particular interest in the Carmel coastline and the back country between Monterey and Salinas. Several major works from this period depict scenes in those regions. Other trips included cross-country drives to the East Coast and several painting vacations to Utah with George Gibson.

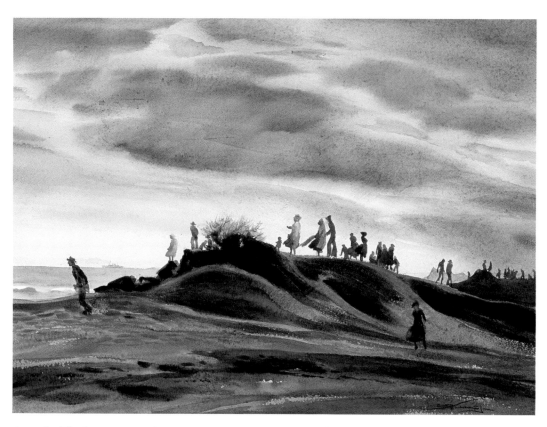

Down by The Sea. Watercolor 18 x 25. Mrs. Lee Witte Collection.

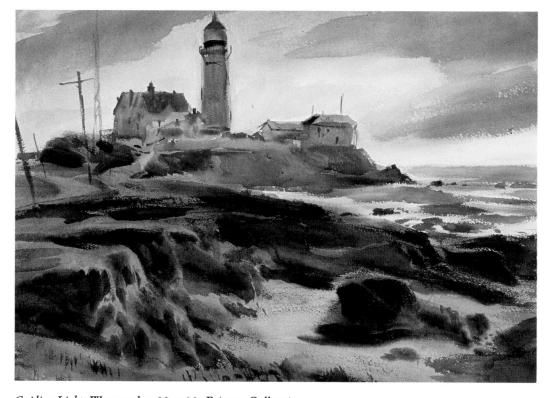

Guiding Light. Watercolor 22 x 30. Private Collection.

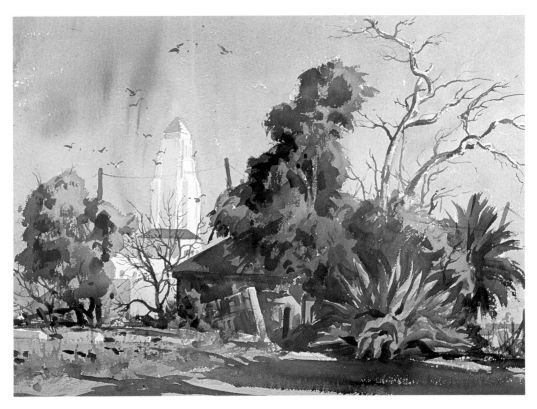

Giant Agave. Watercolor 22 x 30. E. Gene Crain Collection.

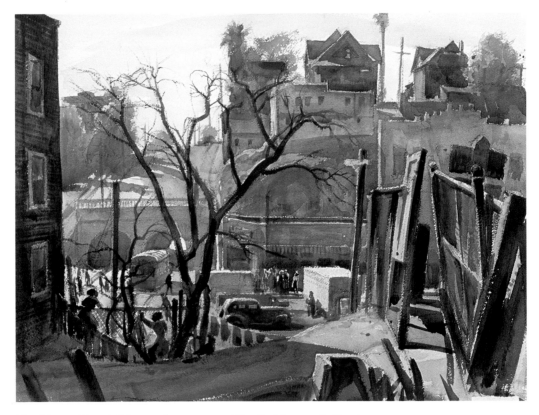

Third Street Tunnel. Watercolor 22 x 30. The Fieldstone Collection.

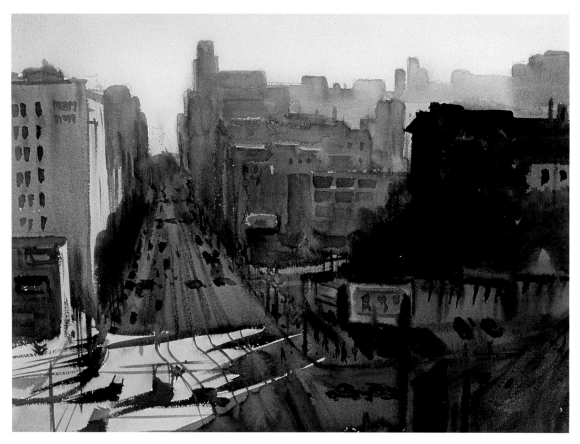

Hill Street. Watercolor 22 x 30. Private Collection.

During the summer of 1949 Kosa took one of these painting excursions to Mexico with Lenard Kester. First they visited Guaymas, then Hermosillo and finally an out of the way town named Alamos. At that time Alamos was still primitive, much like most of Mexico in the nineteenth century. Each day for two and a half weeks they painted as the local residents looked on.

Throughout this whole trip the weather was extremely hot, particularly during the day when they were painting. It was also dry, which caused the water in the watercolors to evaporate and dry quickly. As a result Kosa's paintings from this trip look different than others from this era since he adapted to the conditions and worked in a very dry brush style.

The decade of the 1940s closed for Kosa with a major one-man show at the Cowie Gallery in Los Angeles. It was a celebration marking the gallery's twenty-fifth anniversary. In the catalog for this show Alexander Cowie wrote: "In a time when so many artists turn in upon themselves and produce work of a somber brooding kind, Kosa's exhuberance is tonic and infectious. No matter how troubled and dark the world, the earth is fair, the sun warms. This is what his paintings say to us."

4

THE 1950's

For Americans the transition from the post-war 1940s to the optimistic 1950s was dramatic because they didn't want to keep anything to remind them of the Great Depression or World War II. Antique furniture was thrown out or painted over. Book shelves were cleared to make way for television sets. And in many homes, representational works of art were replaced by abstract paintings or prints.

In California this change directly affected the positions many conservative artists held. In extreme cases art professors, with traditional viewpoints, were laid off and found themselves working at menial jobs. Virtually all of the West Coast museums sold off prime paintings by early California artists. Most annual museum exhibits would only accept works considered to be modern. Through this change Kosa managed better than many of his contemporaries; he continued to receive occasional awards from conservative group exhibits and received at least one major exhibition of his works per year.

After his wife Mary passed away in 1951 Kosa went through a period of deep depression. As he worked through his feelings, his art was affected in several ways. Some days he would go out on location and paint his classic representational works of art. Other days he would stay in his studio and paint large, modern, non-objective works reminiscent of his student art, produced while studying with Frank Kupka. These works were exhibited a few times, but met with little public interest.

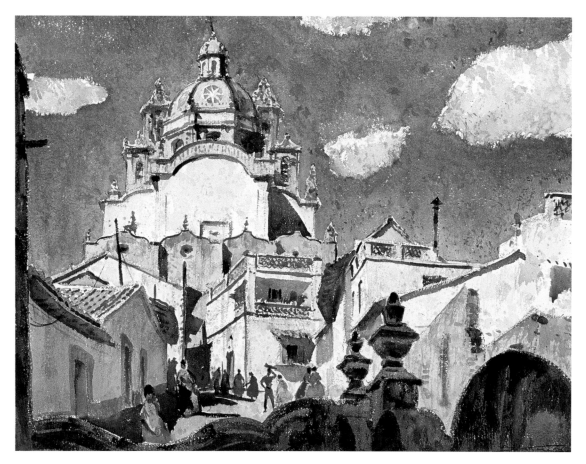

Majestic. Watercolor 22 x 30. Private Collection.

In 1952 he traveled to Paris and married Elizabeth Twaddel an accomplished ballet dancer. She became the subject of some ten portraits and a series of large oil paintings depicting ballet dancing over the next sixteen years.

For most of Kosa's career his primary art agent was Alexander Cowie. The Cowie Gallery was located at the Biltmore Hotel in downtown Los Angeles. As visitors entered the lavish "Peacock Alley" lobby, they would see a display of Kosa paintings. Once or twice a year he would have a one-man show in the gallery. The majority of these shows featured oil paintings which always sold better than watercolors.

Despite the possibility of less income, Kosa, during the 1950s concentrated on painting with watercolors and produced some of the finest aquarelle paintings he would ever create. He had great confidence in his ability to do exactly what he wanted with the watercolor medium and this was evident in his works. He had long ceased to be intimidated by large sheets of watercolor paper and rarely used anything smaller than 22 by 30 inches. He preferred to paint on 300 pound Arches paper. His paints were the finest quality permanent colors available.

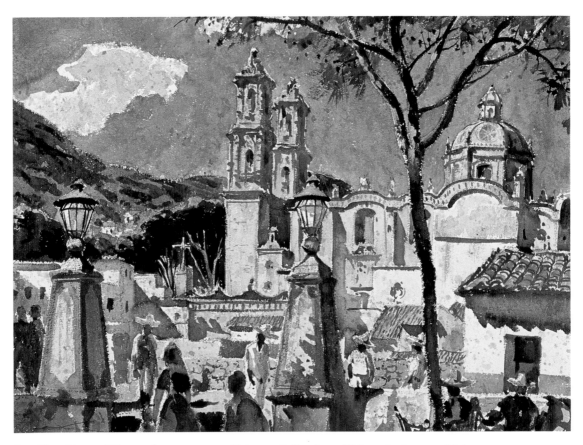

Sparkling Taxco. Watercolor 22 x 30. Private Collection. This painting could be considered a definative California Style watercolor. Kosa used broad sweeping brush strokes on a large sheet of paper. The colors are clean, crisp and transparent. He creatively used the white of the paper to define shapes and work as color. It was painted on location and has a spontaneous feel.

In previous years, Kosa had concentrated on painting in Southern California with occasional trips to other areas of the Southwest. This was due primarily to his busy work schedule at the studios. During the 1950s he found more time to travel. He and George Gibson went to Mexico several times and came back with many fine watercolor paintings. These works reveal Kosa's ability to alter his style of painting to capture more distinctly the feeling and beauty of each location. This ability is also apparent in the series painted on a trip he took to the Hawaiian Islands with his wife Elizabeth. The tropical foliage and bright colors dictated a totally new approach. On Oahu he directed his attention to capture the intense light reflected off the sand and the deep shadows beneath the palms. The misty rain and tropical plants of Kaui called for painting wet into wet, while local Hawaiian tin-roofed houses on the Big Island were painted dry brush. This ability to adapt, change style at will and consistently produce high quality works helped Kosa maintain his position as one of the premier aquarelle painters in California.

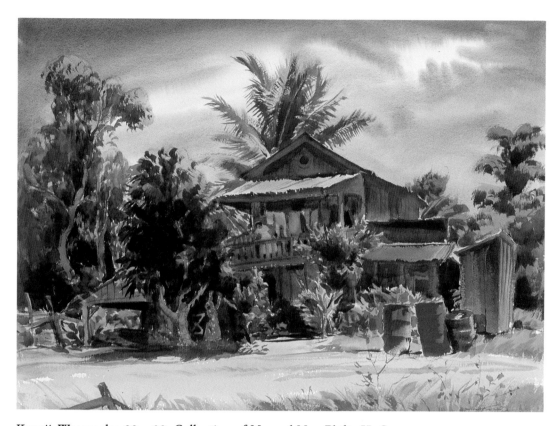

Kawaii. Watercolor 22 x 30. Collection of Mr. and Mrs. Philip H. Greene.

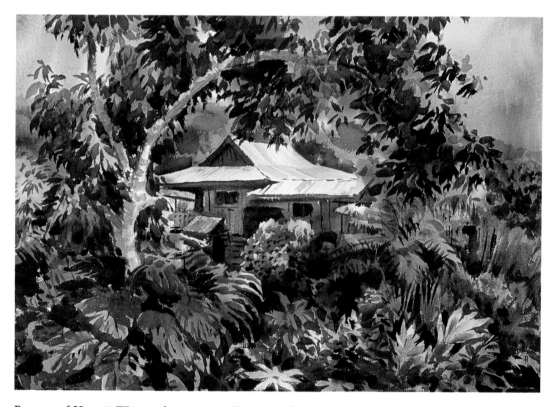

Romance of Hawaii. Watercolor 22 x 30. Private Collection.

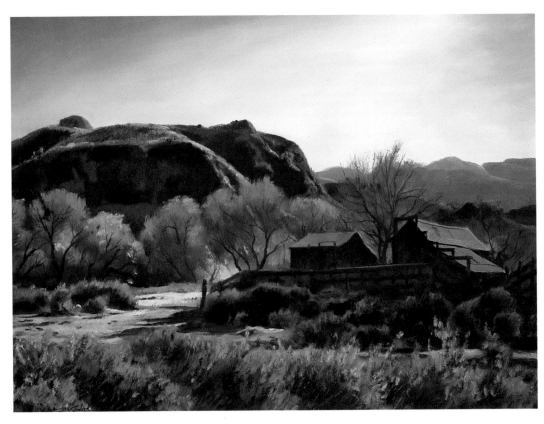

Roof Tops And Mountains. Oil on canvas 28 x 38. DeRu's Fine Arts.

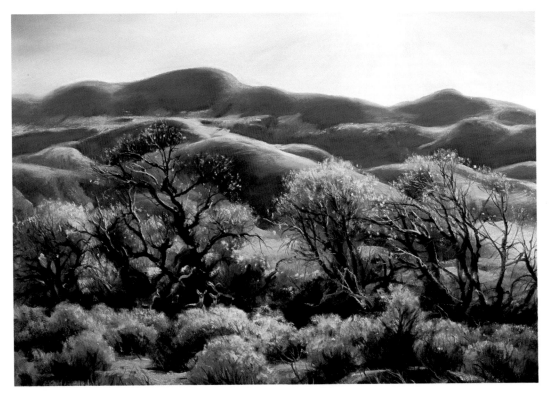

Late Fall. Oil on canvas 24 x 36. Private Collection.

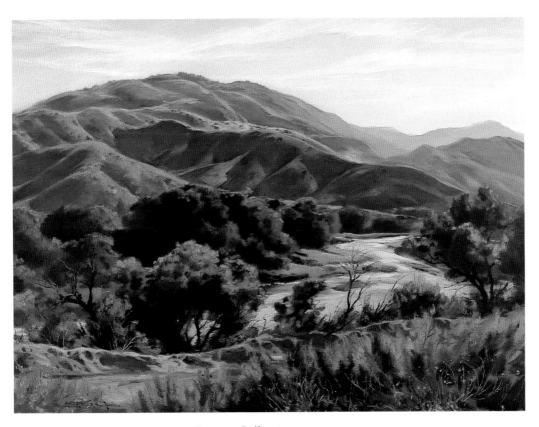

St. Clara. Oil on canvas 30 x 40. Private Collection.

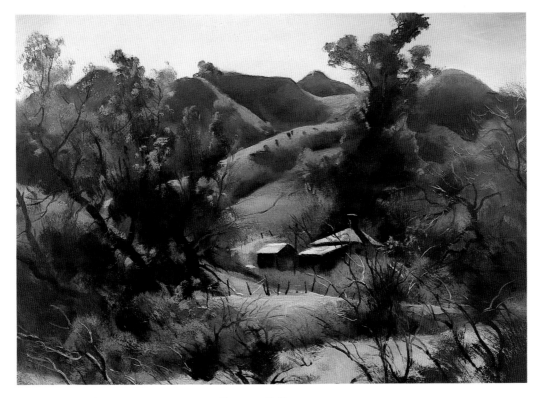

Pico House. Oil on Masonite 27 x 37. Private Collection.

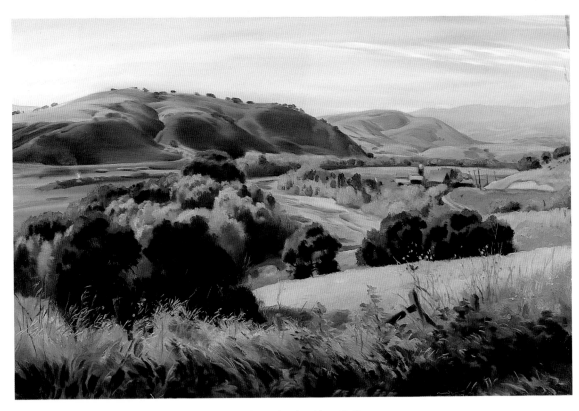

St. Ynez Valley. Oil on canvas 24 x 36. Frank and Julia Tan Collection.

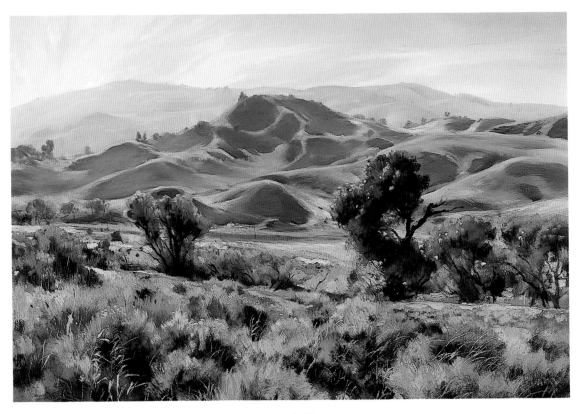

Lasting Happiness. Oil on Masonite 26 x 38. Private Collection.

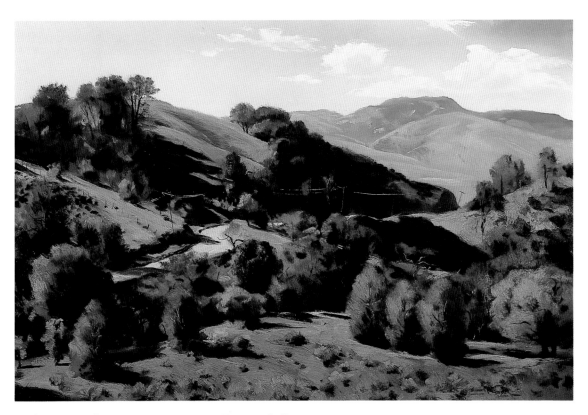

Perfect Day. Oil on Masonite 24 x 36. Private Collection.

Kosa was employed by the Twentieth Century-Fox Studios in Beverly Hills from 1933 until 1968. Their special effects department was an acknowledged leader in the field of motion pictures and particularly in the area of matte shot art. For the thirty-five years he was at the studios, Kosa worked as a matte shot artist and art director. His boss, Fred Sersen, was strict and demanding. He was also an immigrant of Czechoslovakian descent and brought with him many old-world ideas regarding employer-employee relations; workers were unquestionably subservient to their supervisors and expected to work long hard hours. Kosa, raised this way, shared these values. This dictatorial attitude won them no popularity contests, but the department was extremely efficient and the quality of their product was highly respected throughout the motion picture industry.

The Twentieth Century-Fox Studios produced many outstanding films during the era Kosa was employed. Virtually every film that was made at this studio went through the special effects department. Some of the memorable ones include *The Grapes of Wrath, Crash Dive, The Razors Edge, Deadline-USA, The Robe, The King and I, Journey to the Center of the Earth, The Day the Earth Stood Still, Cleopatra* and *Fantastic Voyage.*

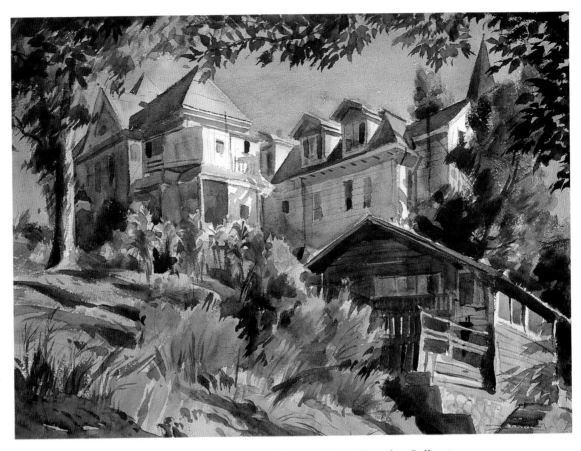

Recollections Of Past Perfect. Watercolor 22 x 30. Glen and Pam Knowles Collection.

Kosa's primary job was to produce paintings for matte shots. When live action film was shot on the studio lot, certain camera angles would reveal that the studio sets and props ended and behind them were, say, telephone poles or office buildings down the street. After this film was developed the lab would take these sections of film, make enlargements and deliver the prints to Kosa. He would black out the usable areas and paint over those that were undesirable, filling in with whatever background scenery the film called for. If it was a downtown New York City scene he might paint a facsimile of the city's skyline. If the shot was to be in Colorado he might paint in mountains and trees. When he finished these matte paintings, they would be filmed and then the two sections, live footage and painted backgrounds, would be meshed together at the lab to produce the final product.

Many other types of paintings were required for more complex effects. Kosa worked closely with several cameramen in a concerted effort to continually improve the process. Their experiments in the pre-World War II era, involved developing custom camera lenses to accomodate varied painting textures on the surface of paper matte

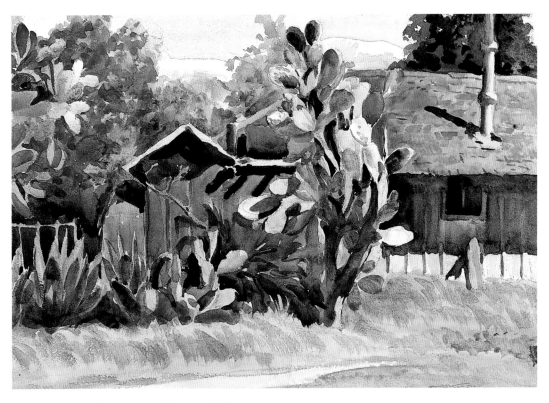

Cactus. Watercolor 15 x 22. Private Collection.

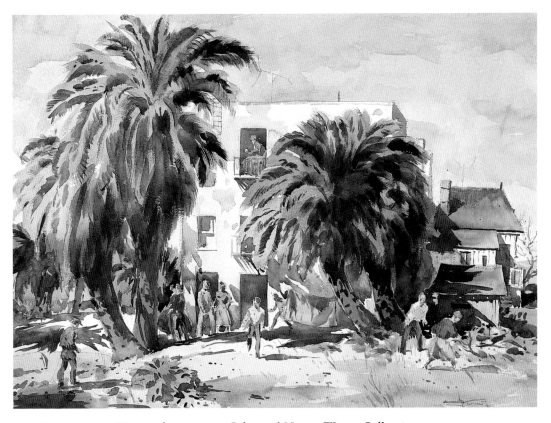

Lazy Summer Days. Watercolor 22 x 30. John and Nancy Weare Collection.

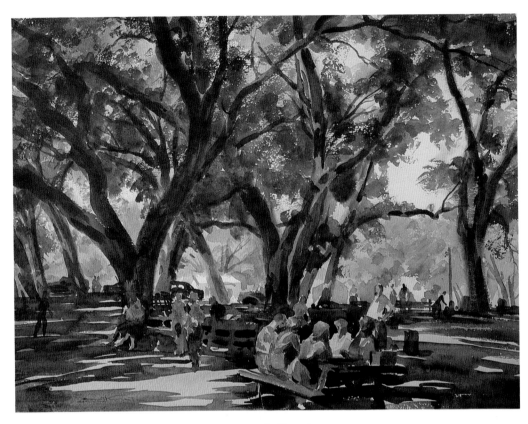

Lunch In The Park. Watercolor 22 x 30. Young's Fine Arts.

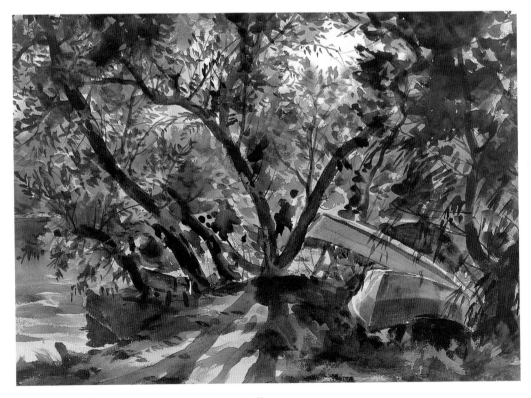

Summer Idyl. Watercolor 22 x 30. Private Collection.

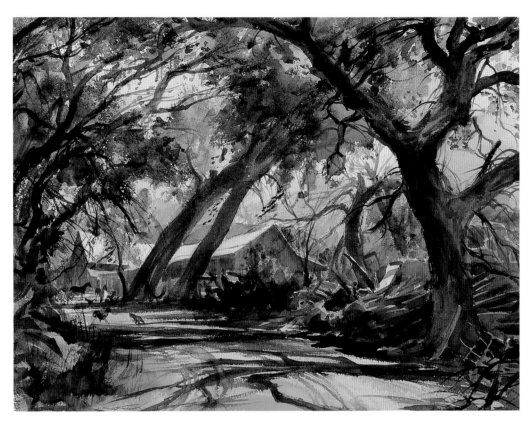

Trees Form An Arch. Watercolor 22 x 30. Private Collection.

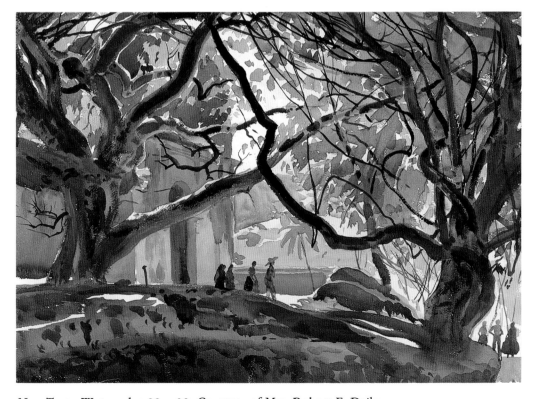

Near Taxco. Watercolor 22 x 30. Courtesy of Mrs. Robert F. Daily.

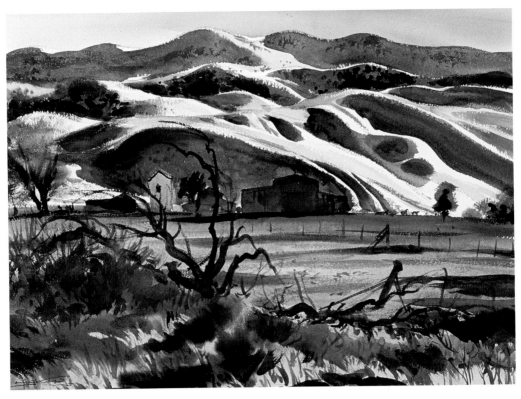

First Snow At Gorman. Watercolor 22 x 30. Private Collection.

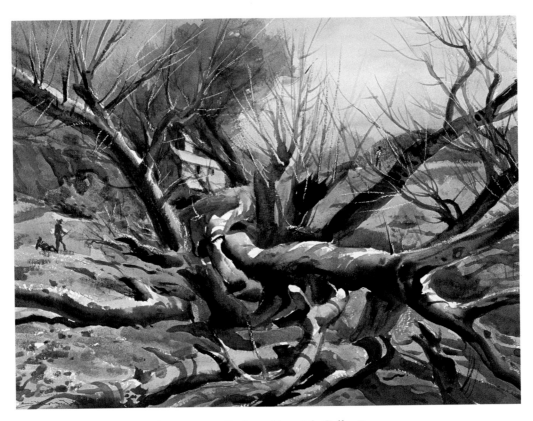

Out On The Farm. Watercolor 22 x 30. Barbara Beretich Collection.

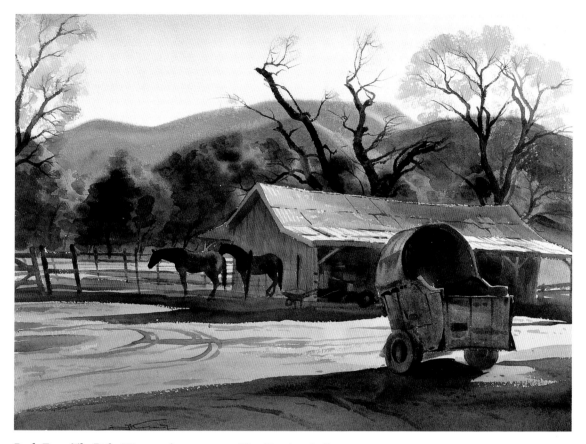

Back From The Ride. Watercolor 22 x 30. The Zander Collection.

boards, tempered Masonite and glass. Today these processes are considered common procedure, but at the time, Kosa and the others at Twentieth Century-Fox were greatly improving old methods and developing many original special effects.

For many years only the people inside the motion picture business were aware of Kosa's contributions. It wasn't until *Cleopatra* was released that he received his much deserved recognition. For the beginning of the film he painted a series of murals depicting a monumental battle scene, which gradually dissolved into live action film. The Academy of Motion Picture Arts and Sciences honored him with an Oscar for his outstanding special effects work.

Kosa also was involved in another aspect of the motion picture business. Whenever the studio needed portrait paintings of the movie stars or important employees, they would rely on his ability to produce a quality portrait quickly. On other occasions his portrait paintings were used on sets in selected movies. His California landscape paintings were also frequently used as props, seen hanging on the walls of homes and offices in a number of Twentieth Century-Fox productions from the 1940s and 1950s.

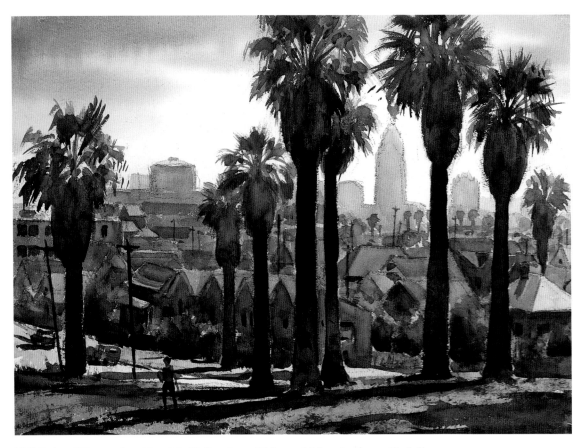

Tall Palms. Watercolor 22 x 30. Collection of Mr. and Mrs. Anthony Podell.

For many artists, working on production art for the motion picture studios ended their interest in fine art painting. The heavy demands from the studios to produce massive amounts of art on a daily basis left them with little energy to paint works for gallery sales and museum exhibitions. Kosa, however, did his studio work and was able to produce as much high quality art as any of his peers on the West Coast. He lived in Los Angeles near the studio and on occasion became inspired by things he saw near his home and in downtown Los Angeles. Bunker Hill, the railroad yards near Alameda Station and the Boyle Heights area were all favored locations. Some of his early paintings depict the Red Car electric trains, once used as local public transportation. Others show the spectacular old Victorian homes, the Los Angeles Gas Works tanks and the clean suburban bungalows that once lined the outskirts of the downtown area. Often in the distance he would include the tall narrow City Hall building that once towered over everything else in the city. George Gibson, who accompanied Kosa on many of these inter-city painting sessions recalled:

"Emil and I would get all excited about painting around L.A. and for several weeks that's all we would paint. I remember the old plaza near Olvera Street where all the drunks and vagrants sat around. It was

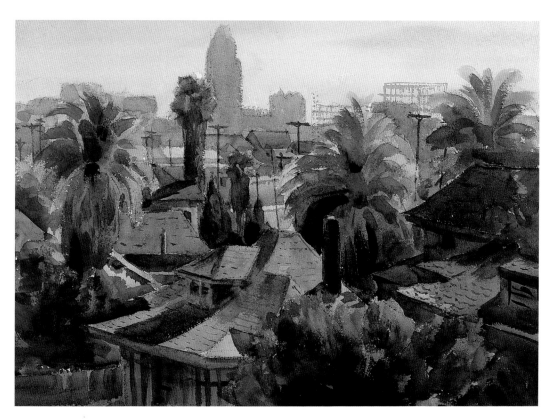

Rooftops. Watercolor 22 x 30. Private Collection.

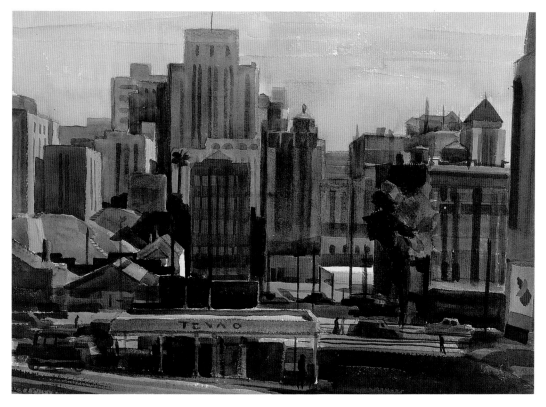

Los Angeles. Watercolor 22 x 30. Private Collection.

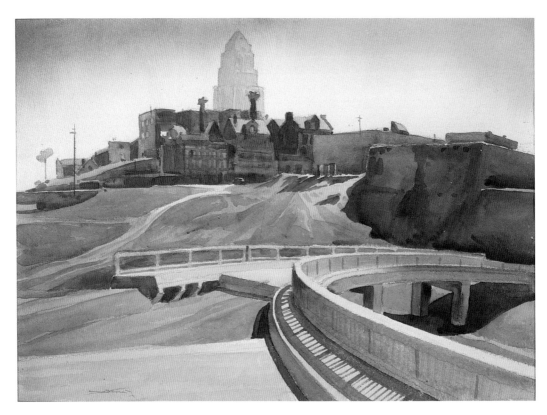

Freeway Beginnings. Watercolor 22 x 30. The Buck Collection.

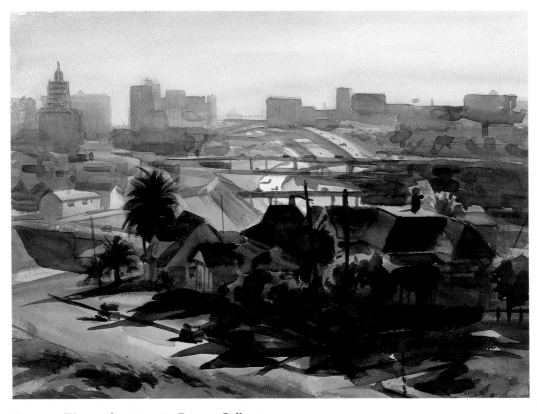

Freeways. Watercolor 22 x 30. Private Collection.

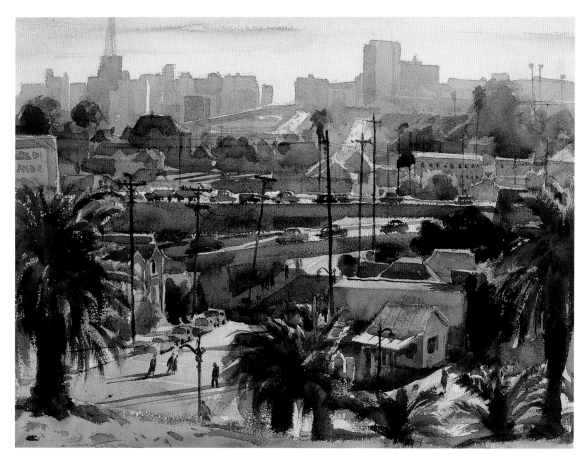

Skyline *Patterns*. Watercolor 22 x 30. Collection of Mr. and Mrs. Philip H. Greene.

crowded with people and the shade from the large trees made nice patterns. We painted there a lot. At lunch time we would get sandwiches at Philippes, then paint all afternoon. The Temple Street area was another place we liked to paint, then there were those beautiful old houses and cactus and big trees on Bunker Hill; it was an artists paradise."

As Los Angeles grew and changed during the 1950s, Kosa continued to set up and paint watercolors at his favorite locations. Some paintings show the ruins of the late nineteenth century Victorian homes after they were demolished, while others depict the new freeway structures and high rise buildings under construction. He made a number of paintings depicting the sweeping freeway forms and cloverleaf intersections as they cut through, arched over and tunneled under existing homes and buildings throughout the city. In his March 1959 one-man show Kosa featured a series of works depicting these local, regional subjects, painted in the classic California Style of watercolor painting. This exhibition, all watercolor paintings, was held at the Cowie Gallery. It included other selected works from the 1950s, in all, some of Kosa's best work of the decade.

5

1960–1968

During the final eight years of his life Kosa remained very productive. He continued to paint on location, often with close friends. There was an extended painting trip to Mexico with Millard Sheets, several excursions to Arizona and many local sessions with George Gibson. Usually these were two or three day trips to secluded ranchland areas in Southern and Central California. North of Los Angeles near Gorman is an area called "Hungry Valley" which for more than thirty years provided seemingly endless landscape subjects and changing weather patterns. Antelope Valley, Solidad Canyon, Buellton, and the Palm Springs area were also regions he visited repeatedly.

On these daily outings Kosa took large canvases up to 30 by 40 inches. They would be anchored down so gusts of wind would not blow them away. He then proceeded to aggressively paint a complete work in one or two day sessions. Throughout his entire career Kosa stood up while painting and often used large sweeping gestures when laying the paint down. He was an excitable man with a romantic nature. The sight of a magnificent sunset or falling sheets of rain on a distant horizon could evoke a deep emotional response. These events often became the inspiration for the dramatic landscape paintings he produced in the early 1960s. Nearly all of these were painted with oils, some on stretched canvas and others on Masonite panels.

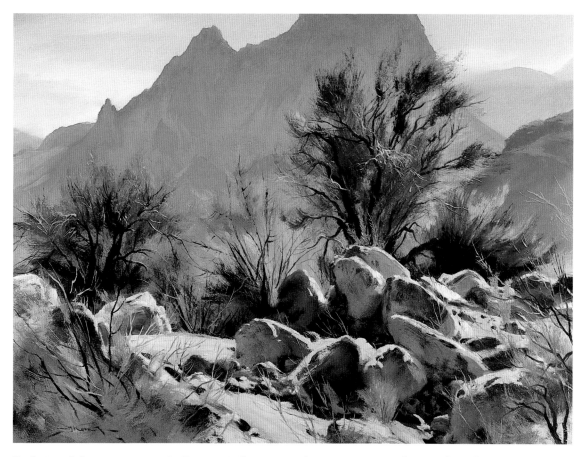

La Quinta. Oil on canvas 30 x 42. Private Collection. In the 1960s Kosa made a number of painting trips to the Palm Springs area. The mountains depicted in the above painting are in an area called La Quinta. They captivated his interest and became the subject of many drawings and a few major oil paintings.

In 1965 Kosa and his wife Elizabeth traveled to Europe. They visited Portugal, Czechoslovakia, France and Italy. In each major city Kosa set up his easel and produced large oil paintings. He kept a rigorous working schedule; painting all morning and afternoon. His only breaks were to enjoy elaborate gourmet lunches, a luxury he enjoyed as often as possible.

This series of European city-scape views was produced for a major one-man show planned at the Cowie Galleries in Los Angeles. Many of these works show a marked departure from the dark green and brown landscape paintings for which Kosa was so well known. They were bright, colorful and often include crowds of people in downtown city areas and seaside resorts. Previously he depicted these subjects when working with watercolors, but rarely had he chosen to work this way with oil paints. Several months after the Kosas returned to California, the Cowie exhibition went on as planned. It was a popular and successful showing.

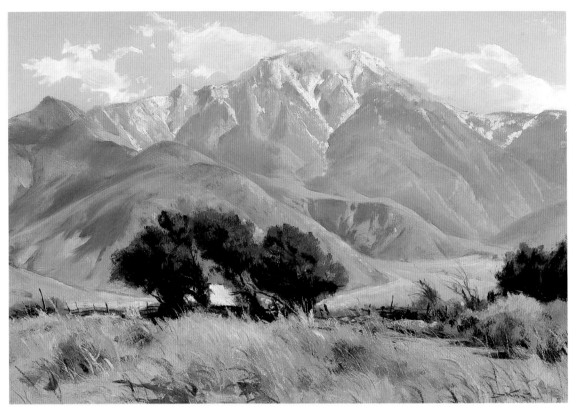

Blue On Blue. Oil on canvas 24 x 36. Michael and Nancy Rupp Collection.

During the early 1960s Kosa was called upon to make public appearances. He traveled to museums throughout America to serve as a judge, selecting works of art that were to receive awards in competitive art exhibitions and taught landscape painting classes in Laguna Beach. KNBC produced a television program titled "Dialogues In Art" featuring a taped interview with Kosa. Also on occasion he was asked to lecture about his personal views on the subject of art. Usually these were presented at art-club meetings or special art-school gatherings. They were well planned programs, presented with great enthusiasm. The following is one such lecture, written by Kosa at the height of his career.

"The things that I might say about art cannot be "brand new", as art, inasmuch as it is the expression of a sensitive personality, is also social— the reflections of a people and its cultural powers, refinements and nobleness, as has been evidenced in the history of mankind. A genius is the supreme manifestation of the potentialities of a great people. The golden age of Phidias was the result of the evolution of the Greek culture. A Newton could not spring up from the Eskimos, a Michaelangelo from the Indians, or a Shakespeare from the Hottentots. I say this because a genius is a part of an era and if I am also a part of that same era, there is an affinity, a proper relation, that I can rejoice in.

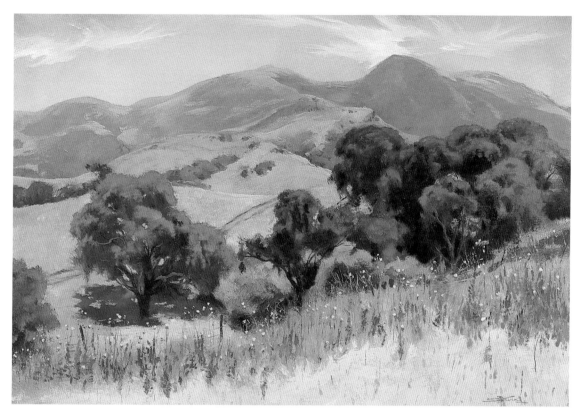

Thistles and Shade Trees. Oil on canvas 26 x 38. Frank and Julia Tan Collection.

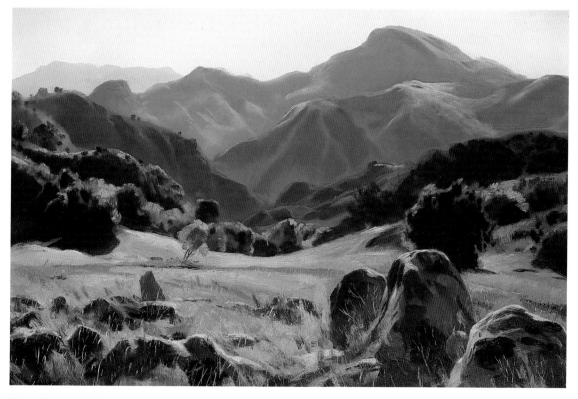

Deer Country. Oil on canvas 24 x 36. DeRu's Fine Arts.

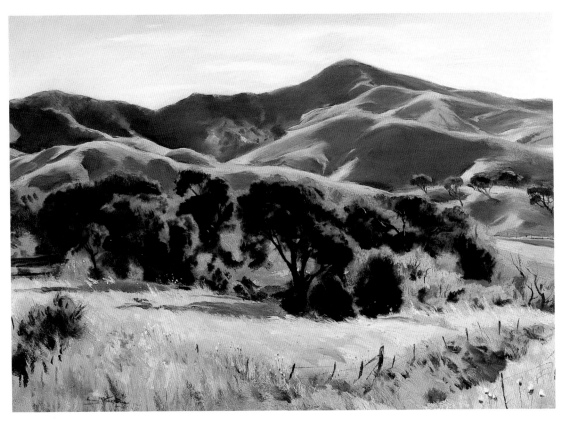

Romance In Gold And Green. Oil on Masonite 27 x 38. Private Collection.

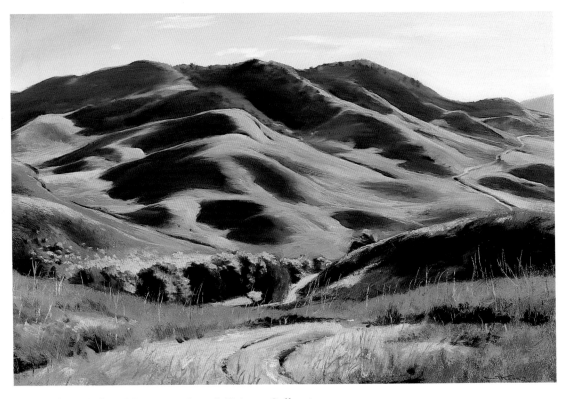

Westward Ho. Oil on Masonite 24 x 36. Private Collection.

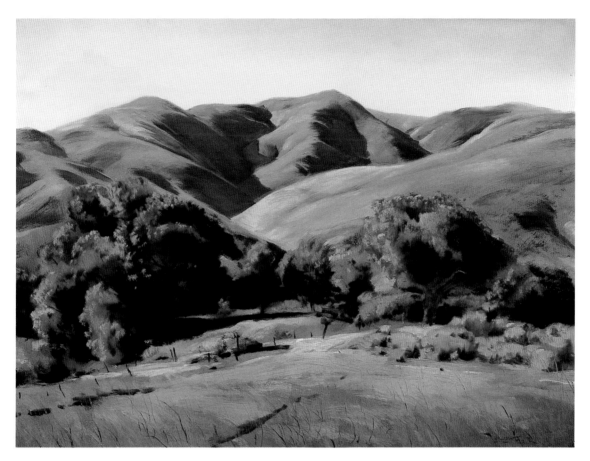

Tout Compris. Oil on canvas 30 x 40. Private Collection. Kosa's oil paintings depicting California's golden brown hills were his most popular works of art in the 1950s and 1960s era. The above is a plein air painting of the region between Los Angeles and Santa Barbara, an area Kosa often chose when going out doors to paint.

Now this all sounds like a bunch of phrases to start my simple talk with, but I'd like to impress upon you the interesting fact that an artist and his work is not something for him alone to be proud of or responsible for, but that he shares all his emotion and responsibilities with you; that you are a distinct part, an integral factor in anything that he does and produces. Like it or not, but an artist reflects like a mirror that which in his life the people are or are not. Just as a form of government and its school system do too. It's the people, always the people.

Now, if they are a liberty-loving people, individualistic, with a sense of good organization and generous, they will reflect all their qualities in their cultural leaders, and they will support their arts, not in a patronizing spirit, but because of an enobling aesthetical hunger that they must satisfy. Now this is not a sales talk, or I should have to talk about the survival of the fittest to save my skin. Of course we could say that an artist is a sort of an educator, but when absolutely honest with myself, I will call it personal advertising.

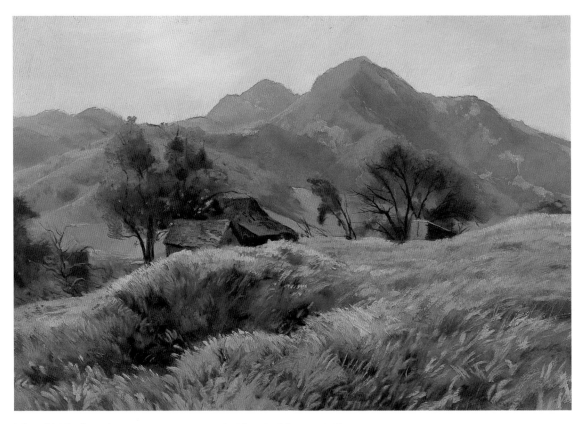

The Old Shack. Oil on Masonite 24 x 36. Alec Goldstein Collection.

Well, why not? We are what we are and we always have a chance to better ourselves. Religion, philosophy and art are magnificent human accomplishments, and if we understood them better, there would be more mutual love and understanding in the world and less war, murder and bloodshed. Ah, we all admit it, but do not do enough about it.

But let's get back to this art business. Now, why do we make art? Why do we like art? Because we naturally must, and I think, because we believe in God. I can't conceive of an atheist being a really great artist. He could not be spiritual enough; his defeatist concept would not allow him to be a pure idealist, a dreamer.

Yes, we believe in the Great Creator, and we believe that we have been created in his image. We like to emulate the greatness that we see in him. We seek everlasting life. We strive for goodness and perfection. We create mysterious situations, with the desire to perpetuate and glorify anything connected with ourselves and our experiences in life. We seek and find and create and appreciate. Life becomes richer. The individual's reaction to a full comprehension of extraordinary values, so mysteriously contained in life, for him to see, if he wills are significant, more refined and deeper. He can see the constant re-ordering of things in nature and in life, and he searches for a finer re-ordering, intellectual, spiritual, emotional; he brings order out of chaos.

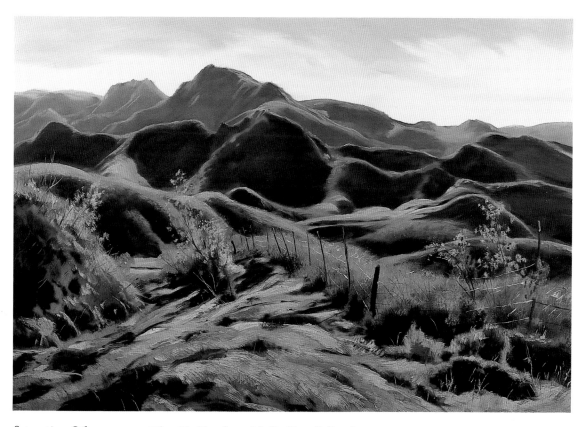

Separation. Oil on canvas 26 x 38. Frank and Julia Tan Collection.

An artist organizes all these experiences into definite forms. This all could get us into a lot more statements more or less universally accepted; for example, that a work of art is the finest, deepest, most significant expression of rare personality; that a creative form must give life to its expression; that drawing is the foundation of painting here I am talking as a painter; that painting is the emotional heightening of a form through the medium of color; that a form contains shapes, directions and contrasts; and that subjects in art are inexhaustible; that nature are things in nature, as distinguished from artificial or art a man's arrangement of natural forces; and that everything is an illusion anyhow.

But that all still does not show what art is or is not. But we know that art ceases to be art when it submits to a formula. For art more than any other thing in life is the symbol of a free spirit, and that spirit emits charm and poetic power that is so necessary to a sensitive dreamer. And dreams, spiritual dreams, are hopes based upon imagination. And its only restrictions are the senses through which we realize all our aesthetical reactions; the senses of touch, smell, taste, hearing and seeing. If through these senses we are aroused to an appreciation of an entirely new emotion, then we have hit upon an aesthetic experience.

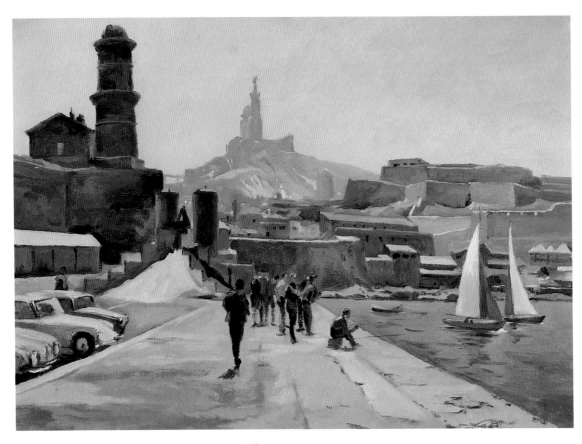

Marseille. Oil on canvas 21 x 29. Private Collection.

However, that experience should not be based upon pure representation. For representation is somewhat like realism, as opposed to that poetical freedom of which I spoke. And that freedom is very important; for it allows us to enjoy a line, a gleam of metal, a pecularity of a piece of texture, an arrangement of forms in itself, and not only the subject it represents for its reality. A photograph presents only the facts of life, conveying information with which we are already thoroughly familiar, cold, objective, with no aesthetic emotions. But we can experience something entirely different from seeing a Japanese print, a Chinese or a Persian painting or a piece of Gothic sculpture. It is not necessarily descriptive, but it translates an important mood.

If our concepts are ordinary, our pleasures will be ordinary; if our concepts are refined pitched high with spiritual freedom, our pleasures will be more refined. We could satisfy our physical hunger with plain food, but as our tastes become more delicate and sensitive or choosy, we will delight in piquancies of a master chef . . . Which brings us to the appreciation of modern art; and modern art has the qualities of that spiritual freedom of which I just spoke. But it must also have discipline. It can be realistic but it is not academic. It can be abstract, if it has the warmth akin to the human soul. It can be powerful or it can be meek, but it must have that sort of oomph-plus: a spirit.''

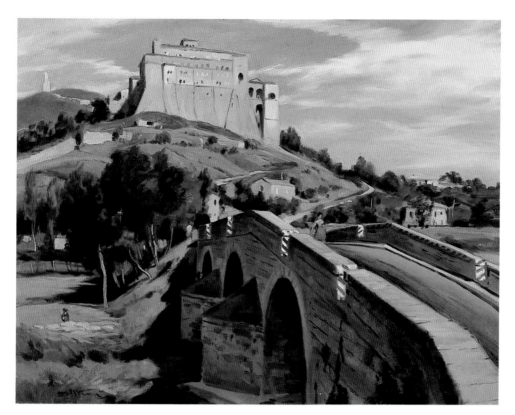

Assissi #1. Oil on canvas 25 x 32. Private Collection.

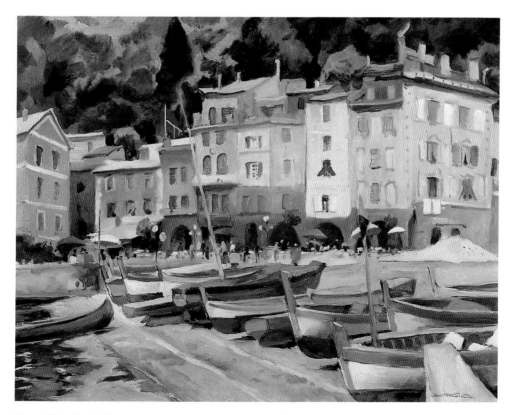

Porto Fino #2. Oil on canvas 21 x 31. Private Collection.

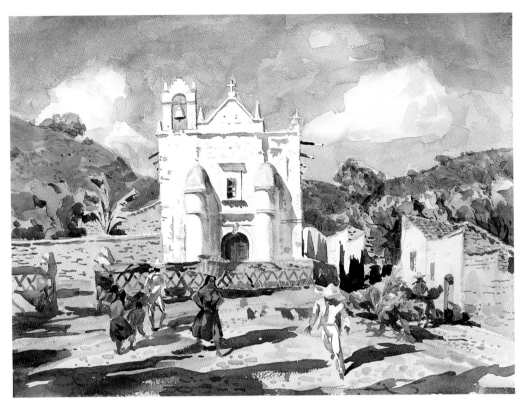

Guadalajara Cathedral. Watercolor 22 x 30. Courtesy of Greg and Cathy Laurie.

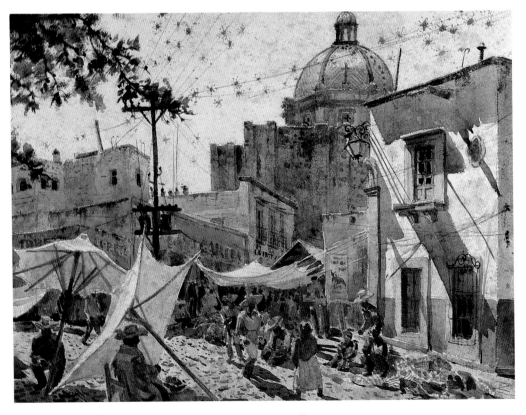

Summer Light-Mexico. Watercolor 22 x 30. Private Collection.

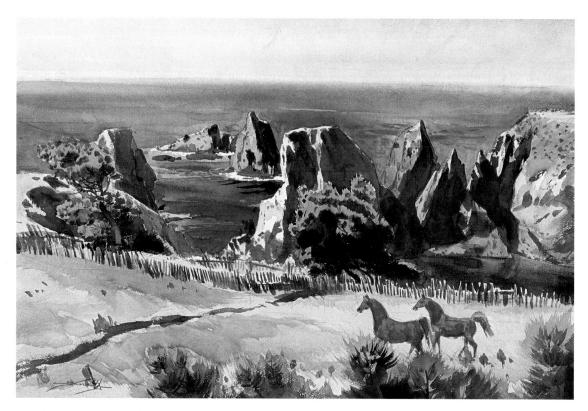

Mendocino #2. Watercolor 22 x 30. Private Collection.

This personal approach to living as an artist was not simply a convenient topic for Kosa to talk about, it was an expression of the life he was leading. The many vibrant paintings and drawings we still enjoy today confirm how he felt and acted upon these principles. Artist Sueo Serisawa noted: "In the midst of the maddening confusion in the world of art and the pursuit of the new and the sensational; it was refreshing to know an individual like Emil Kosa who worked at his own speed and pace. His enthusiasm for life, people and nature was reflected in his art. This quality was contagious to all who knew him."

In 1968 Emil Kosa Jr. passed away. A few months later Alexander Cowie arranged a Memorial Exhibition presenting a retrospective look at Kosa's paintings. His classic depictions of sunlit hills covered with golden brown grass, vivid green pasturelands in the springtime and snow capped mountains towering over the desert floor filled the gallery. Arthur Millier affectionatly labeled these regions "Kosa Country" and wrote: "There is still a lot of Kosa Country left if you get off the freeways and away from the bulldozers. He put down on canvas or paper the way it looked to him, neither stylized nor photographic. His paintings can help you to see Kosa Country as he saw it. Provided you are able to see, as Emil did, with the eyes of love."

Chronology

1903	Born Emil Jean Kosa Jr. in Paris, France. His father, Emil Kosa Sr., and mother, Jeanne, lived in Paris and were active in the thriving Parisian art and music scene.
1907	Kosa's mother passed away. His father remarried and the family moved to Brno, Czechoslovakia (Austria-Hungary).
1908	Kosa family moved to America, settling in Cape Cod, Massachusetts. Emil Kosa Sr. worked with Alphonse Mucha designing posters and painting murals.
1912	Kosa family moved back to Brno, Chechoslovakia.
1917	Kosa family moved back to America, but left Emil to finish his art education at the Academy of Fine Arts in Prague.
1921	Kosa graduated from the Academy of Fine Arts in Prague, then went to live with his family in California.
1922	Attended art classes at the California Art Institute in Los Angeles.
1925	Traveled to Hawaii for the summer months.
1927	Became a naturalized citizen of the United States. Returned to Paris, to study at *L' Ecole des Beaux Arts.*
1928	Finished his art instruction in Paris then went back to Hollywood where he married Mary Odisho. Received a Bronze Medal for a painting exhibited at the Panama-Pacific Exposition in California.
1928-1933	Worked as a mural artist and commission portrait painter. Projects included murals for the Cathedral of the Blessed Sacrament in Sacramento, The Hotel Playa Ensenade, Lakewood Golf Clubhouse, The Casino on Catalina Island, and in The Angeles Temple in Los Angeles. Lived in Sacramento for almost a year.
1930	Kosa's had a daughter, Lillian, who went by the nicknames Bobi or Fanny.
1931	First one-man show of watercolors at the Assistance League Art Room in Los Angeles. Received First Prize award for a watercolor exhibited at the Los Angeles County Fair Art Show.
1933	One-man show of watercolors at the California State Library in Sacramento. One-man show of watercolors and drawings at the Fine Arts Gallery, San Diego, California. One-man show of drawings and etchings at the Crocker Art Gallery in Sacramento. One-man show of watercolors at the Mission Inn Gallery in Riverside, California. One-man show of drawings at the Stendahl Gallery, Los Angeles. First Prize award for a watercolor shown in the Sacramento Community Art Exhibition, California. Traveled to Mexico on a sketching and painting trip.
1933-1968	Employed by the Twentieth Century-Fox Studios, as an artist in the Special Effects department.
1934	First Prize for a watercolor in the Los Angeles Art Association Exhibition.
1935	One-man show at the Hesse Galleries, California.
1936	First exhibited with the American Watercolor Society in New York City.

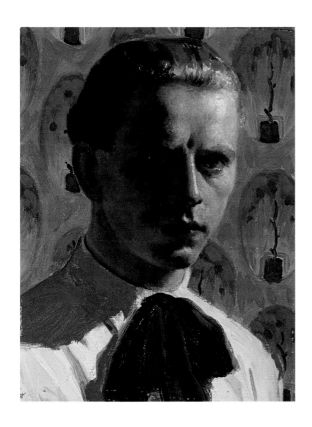

Self Portrait-Youth. Oil on canvas 12 x 9.
Elizabeth Kosa Collection.

1937 First Prize award for a watercolor in the California Art Club Exhibition, Los Angeles. First exhibited in the National Academy of Design Annual show in New York City.

1938 Received the William Church Osborn purchase prize from the American Watercolor Society. First Prize award for a watercolor exhibited at the Oakland Art Gallery, California. First Prize award for an oil painting in the California Art Club exhibition, Los Angeles. First Prize award for a watercolor in the Santa Cruz Statewide Art Exhibition, California. First Prize for a watercolor in the Painters and Sculptors Club exhibition, Los Angeles.

1939 Received Life Membership in the American Watercolor Society. One-man show at the Oakland Art Gallery, California. Guest exhibit at the Denver Art Museum, Colorado. One-man show sponsored by the California Art Club, Los Angeles. Zabriskie purchase prize from the American Watercolor Society. First Prize award for a watercolor in the California State Fair Art Exhibition, Sacramento. First Prize award for an oil painting in the Painters and Sculptors Club, Los Angeles. First Prize award for an oil painting in the Santa Paula Statewide Exhibition, California.

1940 One-man show at the Los Angeles County Museum. One-man show at the Macbeth Gallery, New York City. One-man show at Sacramento State College, California. Five paintings exhibited at the Golden Gate International Exposition, San Francisco. Elected Vice President of Painters and Sculptors Club, Los Angeles. Painting and sketching trip across America to New England.

1941 One-man show at the Biltmore Gallery, Los Angeles. One-man show at the Fine Arts Gallery in San Diego, California. Ranger purchase prize from the National Academy of Design for an oil painting. Purchase prize for an oil painting from the Chafey Community

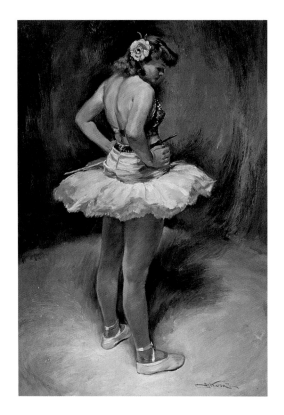

Little Performer. Oil on canvas 40 x 28.
DeRu's Fine Arts.

Art Association, California. First Prize award for oil painting exhibited at the Foundation of Western Art, California. First Prize award for a watercolor in the California Art Club exhibition, Los Angeles. First Prize for an oil painting in the Santa Cruz Statewide Exhibition, California.

1942 One-man show at the Vose Gallery, Boston. One-man show at the Biltmore Gallery, Los Angeles. One-man show at the Maxwell Gallery, San Francisco. One-man show for the Press Club, San Francisco. First Prize award for an oil painting exhibited at the Foundation of Western Art, Los Angeles. First Prize for an oil painting exhibited at the Oakland Art Gallery, California. First Prize for an oil painting exhibited at the Santa Cruz Statewide Exhibition, California. First Prize for an oil painting exhibited at the California Art Club Los Angeles. First Prize for an oil painting from the Fine Arts Gallery, San Diego, California.

1943 Lillian Kosa, Emil's only child, passed away after battling with leukemia for several years. One-man show at the Biltmore Gallery, Los Angeles. Awarded a Service Honor from the Art in National Defense. This organization was a Special Service Division of the United States Army during World War II. It provided art for military use, exhibitions of fine art works in military buildings and art instruction for recovering service men.

1944 One-man show of watercolors at the Laguna Beach Art Museum, California. One-man show at the Biltmore Gallery, Los Angeles. First Prize award for an oil painting from the Painters and Sculptors Club, Los Angeles.

1945 Elected President of the California Water Color Society. One-man show at the Santa Barbara Museum of Art. Purchase prize from the California Water Color Society. First Prize award for an oil painting exhibited at the Foundation of Western Art, Los Angeles. Painting trip to Utah with George Gibson.

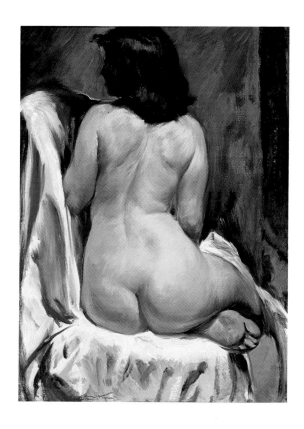

Study. Oil on canvas 30 x 24.
Elizabeth Kosa Collection.

1946 One-man show at the Macbeth Gallery in New York City. One-man show at the Biltmore Gallery, Los Angeles. Purchase prize from the Toledo Museum of Art, Ohio. Painting trip to Utah.

1947 Two one-man shows at the Cowie Gallery in Los Angeles. First Prize award for an oil painting in the Arizona State Fair Art Exhibition. Taught figure painting classes at the Chouinard Art Institute, Los Angeles.

1948 Elected an Associate of the National Academy of Design. One-man show at the Cowie Gallery, Los Angeles. Purchase prize from the Watkins Institute, Nashville, Tennessee. Purchase prize from the Art Club, Oxnard, California. First Prize award for an oil painting in the Arizona State Fair Art Exhibition. First Prize award from the Santa Cruz Statewide Exhibition, California. Honor award from the Audubon Artists, New York City. Taught figure painting classes at the Chouinard Art Institute, Los Angeles.

1949 Nominated National Director of the Southern California Artists Equity. One-man show at the Cowie Gallery, Los Angeles. First Prize award from the National Academy of Design. First Prize award from the Arizona State Fair Art Exhibition. Painting trip to Mexico with Lenard Kester.

1950 One-man show at the Cowie Gallery, Los Angeles. First Prize award for an oil painting exhibited at the Oakland Art Gallery, California. The front cover of *American Artist* Magazine featured a Kosa drawing. Inside was a feature story he wrote on California art and artists. Painting trip through California, Arizona and Wyoming.

1951 Mary Kosa, Emil's first wife, passed away after an extended battle with leukemia. Kosa was elected a Full Member of the National Academy of Design. One-man show at the Cowie Gallery, Los Angeles. Received the Cannon Prize for a watercolor from the National Academy of Design.

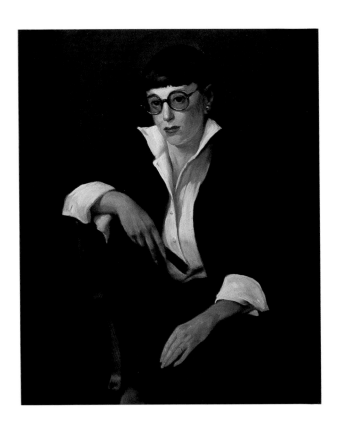

Portrait Of Edith Head. Oil on canvas
30 x 24. Private Collection.

1951-1960 Kosa produced a series of abstract and non-objective works of art, most of which were large oil paintings on canvas.

1952 Kosa married Elizabeth J. Twadell in Paris. Childe Hassam Purchase Award for a watercolor exhibited at the Academy of Arts and Science. Guest instructor at the Brandt-Dike Summer School of Painting in Corona Del Mar, California.

1953 One-man show at the Cowie Gallery, Los Angeles. Received the Harriet Sanford Stuart Memorial Award from the American Watercolor Society.

1954 Received the Adolph and Clara Obrig Award from the National Academy of Design. Painting trip to Arizona and throughout other Southwestern states. Painted a series of commissioned murals for the Lockheed Aircraft Corporation.

1955 Two-man show of paintings with his father Emil Kosa Sr. at the Palos Verdes Art Center, Rancho Palos Verdes, California. Purchase award from the Springfield Museum, Utah. First Prize award from the American Traditional Art Show, Hollywood, California.

1956 One-man show at the Frye Museum, Seattle, Washington. One-man show at the Cowie Gallery, Los Angeles. Painting trip to the Hawaiian Islands.

1957 One-man show at the Cowie Gallery, Los Angeles.

1958 Jarvis House award from the Art U.S.A. Exhibition, New York.

1959 One-man show at the Cowie Gallery, Los Angeles. One-man show at the Massa Gallery, Los Angeles. One-man show at Bakersfield College, California. Painting trip to Mexico.

1960 One-man show at the Cowie Gallery, Los Angeles. One-man show at the O'Brien Gallery, Scotsdale, Arizona. Painting trip to Mexico with George Gibson.

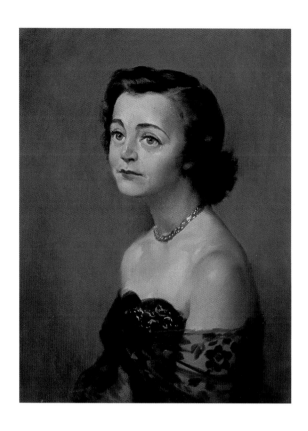

Portrait Of Elizabeth Kosa. Oil on canvas
24 x 18. Elizabeth Kosa Collection.

1961 One-man show at the O'Brien Gallery, Scotsdale, Arizona. Painting trip to Europe. Primarily worked with oils on canvas and produced location paintings depicting scenes in France, Portugal, and Italy.

1962 Traveled to Washington D.C. to paint the official commissioned portrait of Earl Warren. Taught painting classes at the Laguna School of Art, California.

1963 One-man show at the Pierce Gallery, Tucson, Arizona. Painting trip to Mexico with Millard Sheets.

1964 Received an Oscar Award from the Academy of Motion Picture Arts and Sciences, for his special effects work on the movie *Cleopatra.* Painting trip to Arizona. Traveled to Europe to do work on the motion picture *The Agony and the Ecstacy.*

1965 One-man show at the Cowie Gallery, Los Angeles. Painting trip to Europe. He and his wife Elizabeth traveled all over Europe including Czechoslovakia. This was a very productive painting trip which led to an extensive exhibit of European paintings at the Cowie Gallery.

1966 One-man show at the Cowie Gallery, Los Angeles.

1967 One-man show at the Cowie Gallery, Los Angeles. One-man show at the Copenhagen Gallery, Solvang, California. Painting trip throughout the Southwest and into Mexico.

1968 Kosa passed away November 4 in Los Angeles, California.

 In early 1968 the KNBC Channel 4 program "Dialogues In Art" taped an interview with Kosa. It was aired shortly after he passed away. The following year the National Academy of Design awarded a Kosa painting the Henry Ranger Fund Purchase Award and the Cowie Gallery in Los Angeles presented a memorial retrospective exhibition of his work.